LES BRAVADES

A PORTFOLIO OF PICTURES MADE FOR REBECCA WELLES BY HER FATHER

Christmas 1956

AFTERWORD BY SIMON CALLOW

WORKMAN PUBLISHING • NEW YORK

We'd like to thank Rebecca Welles
for allowing this beautiful and intimate gift,
from a father to his daughter,
to be shared by us all.

We also wish to thank Barbara Braun
for her efforts in the publication of *Les Bravades*.

— BART ROSENBLATT & AL CORLEY

Library of Congress Cataloging-in-Publication Data
Welles, Orson
Les Bravades: a portfolio of pictures made for Rebecca Welles by her father
with an afterword by Simon Callow.
p. cm.
ISBN 0-7611-0595-6 (hardcover)
1. Welles, Orson - Notebooks, sketchbooks, etc.
I. Title.
NC139.W43A4 1996
741.942–dc20 96-31192 CIP

Workman Publishing
708 Broadway
New York, NY 10003-9555

Manufactured in the United States of America

First Printing November 1996

10 9 8 7 6 5 4 3 2 1

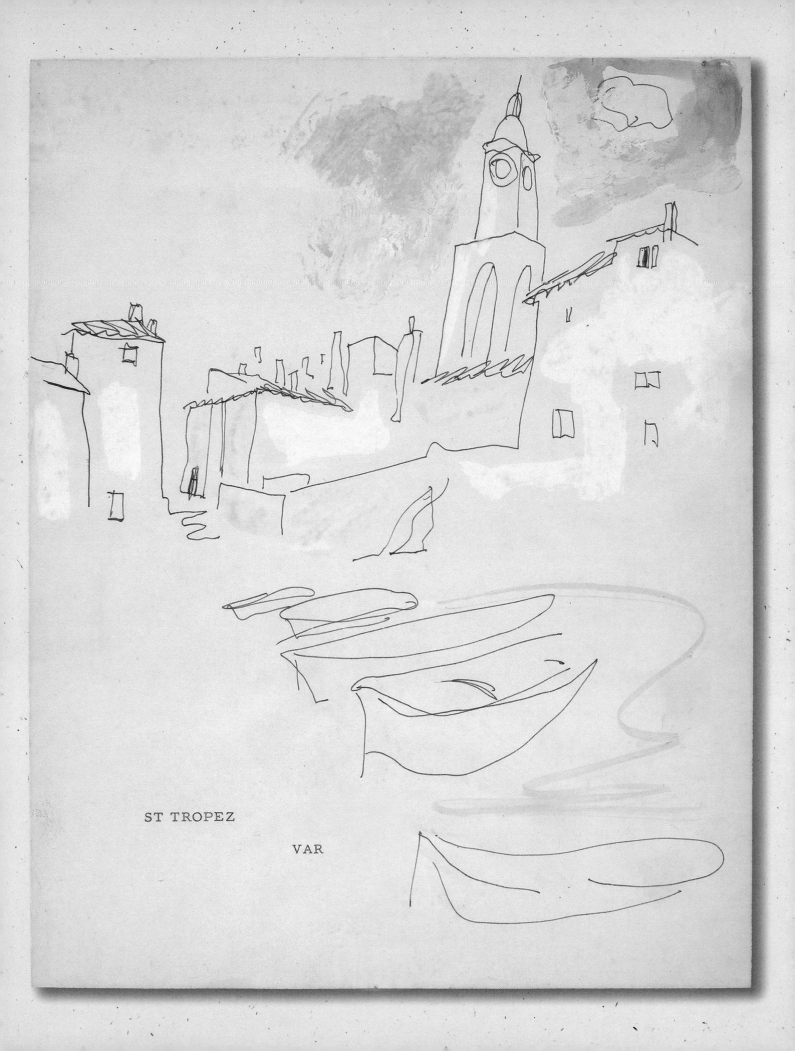

ST TROPEZ

VAR

(Here is the old port)...

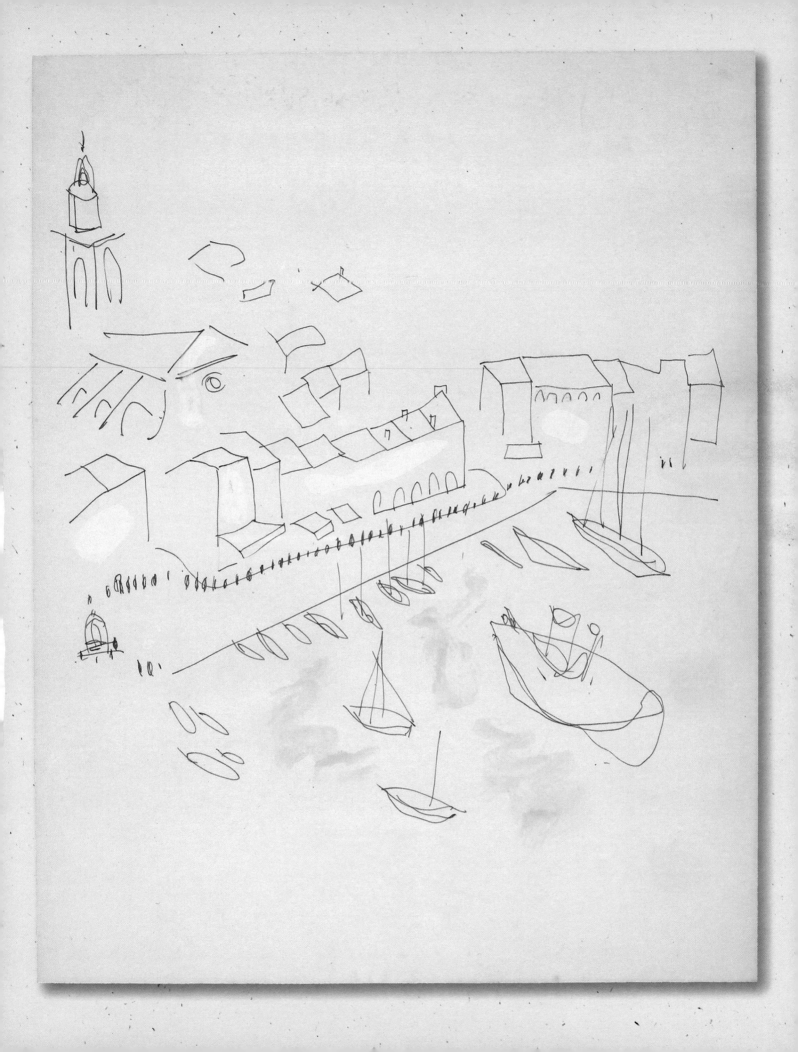

SO MUCH FOR THE TOWN ITSELF ...

ST TROPEZ IS NAMED (as you might guess)

FOR SAINT TROPEZ. HE DIED IN THE TIME OF

THE WICKED EMPEROR NERO.

THEY CUT OFF HIS HEAD IN PISA.

THE HEAD IS STILL THERE, -- not far from

the famous leaning tower. DEVOUT HANDS,

in the early part of the sixteenth century, COVERED

THE SKULL OF THE SAINT IN SILVER LEAF.

IT IS QUITE A SIGHT.

THE REST OF HIS POOR BODY WAS SET ADRIFT

IN A SMALL OPEN BOAT, A COCK, A DOG, A

VIPER AND A MONKEY GOING ALONG FOR THE

TRIP

> (or perhaps these animals were placed
> aboard for some purpose; but if so,
> I dont know what it could have been).

Note:

Anyway, when the voyage
was over the snake and
the ape — being considered
wicked beasts — were dead,
and the rooster and the dog
were feeling fine.

AT LONG LAST, AND AFTER MANY STRANGE

ADVENTURES, THE TINY CRAFT, MARVELOUSLY

RIDING OUT THE MOST TERRIBLE OF STORMS,

WAS CAST UP ON THE SHORES OF THE PRESENT

TOWN OF ST. TROPEZ. (Var)

(Needless to say the town wasnt named St. Tropez
 untill after the arrival of the majority of the holy
 man's remains).

OF THE SPLENDID CHURCH ERECTED AS A

SHRINE TO THAT SACRED AND--Idaresay--

WONDER-WORKING RELIC, NOT ONE STONE

REMAINS TODAY.

 NOT THE ATOM BOMB

BUT THE INFIDEL SARACENS ARE RESPONSIBLE.

IT IS HOPED THAT THE CHRISTIANS WERE SPRY

ENOUGH TO SMUGGLE THEIR SAINT'S BONES

AWAY FROM THE DESECRATING HANDS OF THE

BLOODY MOORS. IF THIS IS SO THEN SAINT

TROPEZ IS STILL AT REST HERE IN THE PRETTY

LITTLE FISHING VILLAGE THAT PROUDLY

BEARS HIS NAME.

BUT NOBODY LIVING HAS THE FAINTEST

NOTION OF WHERE TO LOOK FOR HIS GRAVE...

EVERY YEAR ON THE SAINT'S DAY --

AND FOR TWO DAYS AFTERWARDS, THE

GOOD PEOPLE OF HIS TOWN CELEBRATE

THEIR PATRON AND PROTECTOR WITH A

MOST EXTRAORDINARY FESTIVAL . . .

THIS IS CALLED THE "BRAVADE."

 ¶ I was lucky enough to be in
 St Tropez during this holiday;
 and because i kept thinking of
 you, and wishing you could be
 seeing it too, I've prepared
 this little picture book to give
 an idea what it was like ¶

I'VE SEEN A LOT OF "FETES" "FIESTAS"

AND FESTIVALS, EVERY SORT AND VARIETY OF

SAINTS-DAY HIGH-JINKS ALL OVER THE WORLD.

I'VE BEEN TO SUCH EVENTS IN SICILLY AND CHINA

IN SOUTHERN SPAIN AND ITALY AND ON THE

ALTI-PLANO OF BOLIVIA.

BUT NEVER ANYTHING TO EQUAL THE "BRAVADES"

OF ST. TROPEZ ...

I'VE SEEN THINGS AS BEAUTIFUL AND TRUE

IN THIS LINE, BUT ABSOLUTELY NOTHING AS

COMPLETELY AND UTTERLY UNLIKE ANYTHING

ELSE ON EARTH.

AND NEVER ANYTHING AS SERIOUS AND GAY AT

THE SAME TIME. ¶

ON THE MORNING OF THE SECOND DAY

THERE IS A DANCE ... YOUNG PEOPLE COME

FROM ~~the~~ ALL THE NEARBY TOWNS ...

THE GIRLS WEARING THE SORT OF CLOTHES

YOU SEE HERE ... AND THE BOYS LOOKING VERY

SMART INDEED IN THEIR ~~broad~~ WIDE BRIMMED HATES

Even the smallest children are brave

in miniature versions of the traditional

costumes ...

But the most
important part
of the BRAVADES
are the

BRAVADEURS

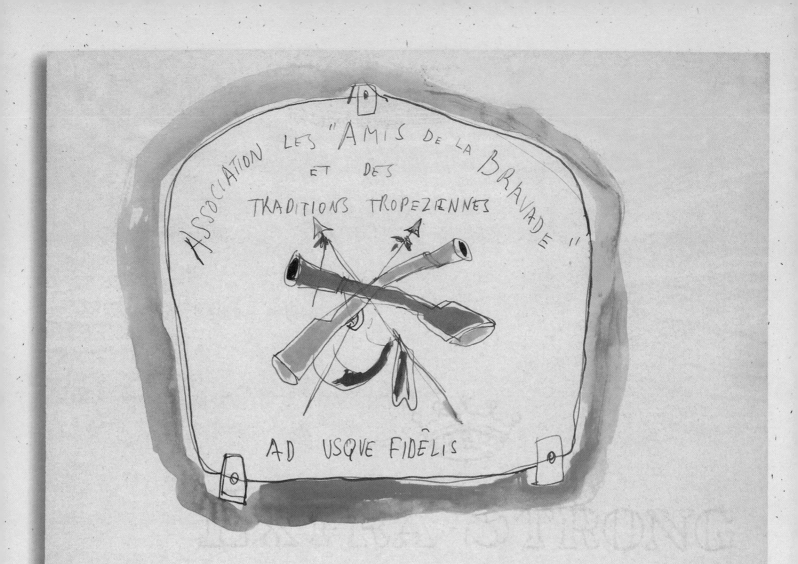

ASSOCIATION LES "AMIS DE LA BRAVADE"
ET DES
TRADITIONS TROPEZIENNES

AD USQVE FIDÊLIS

THE RITES OF THE "BRAVADE" ARE CELEBRATED
BY A SPECIAL ORGANIZATION . . .

THEY EVEN HAVE THEIR OWN CLUB-HOUSE . . .

THE "BRAVADEURS" ARE AN HONORED
GROUP MADE OF LEADING CITIZENS...
THE BUTCHER, THE BAKER
THE CANDLESTICK MAKER,
THE MAN WHO RUNS THE
TOBACCO SHOP, THE
LOCAL DENTIST, THE
SCHOOL TEACHER, AND
OF COURSE, MANY
OF THE FISHERMEN

THEY WEAR AN
EXTRAORDINARY
COSTUME

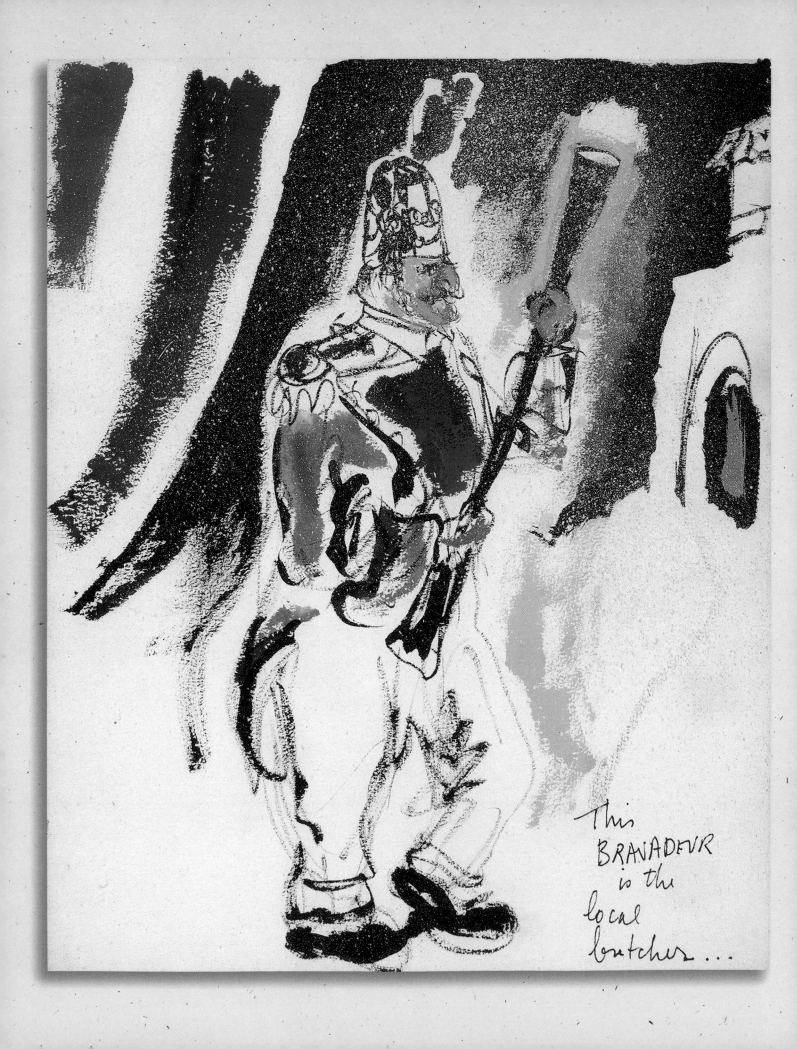

This
BRAVADEUR
is the
local
butcher . . .

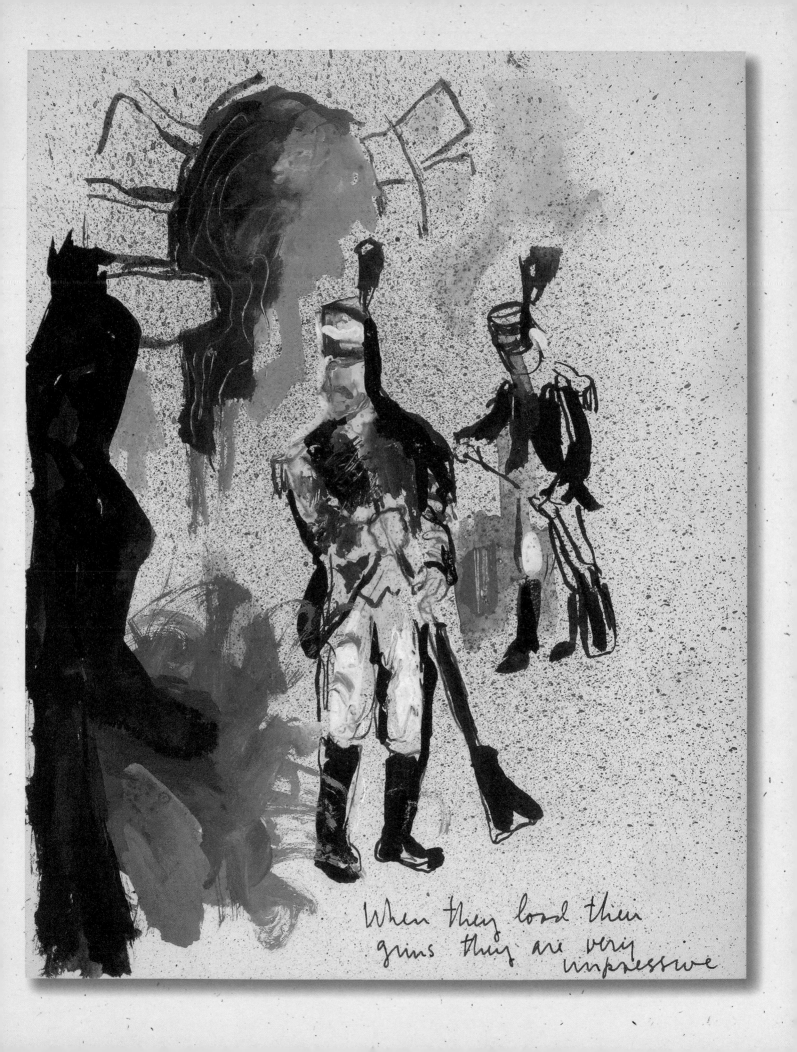

When they load their
guns they are very
unimpressive

SOME OF THE GENTLEMEN

ARE VERY FINE M AND HANDSOME IN THEIR

COSTUMES .. REALLY QUITE NOBLE-LOOKING ...

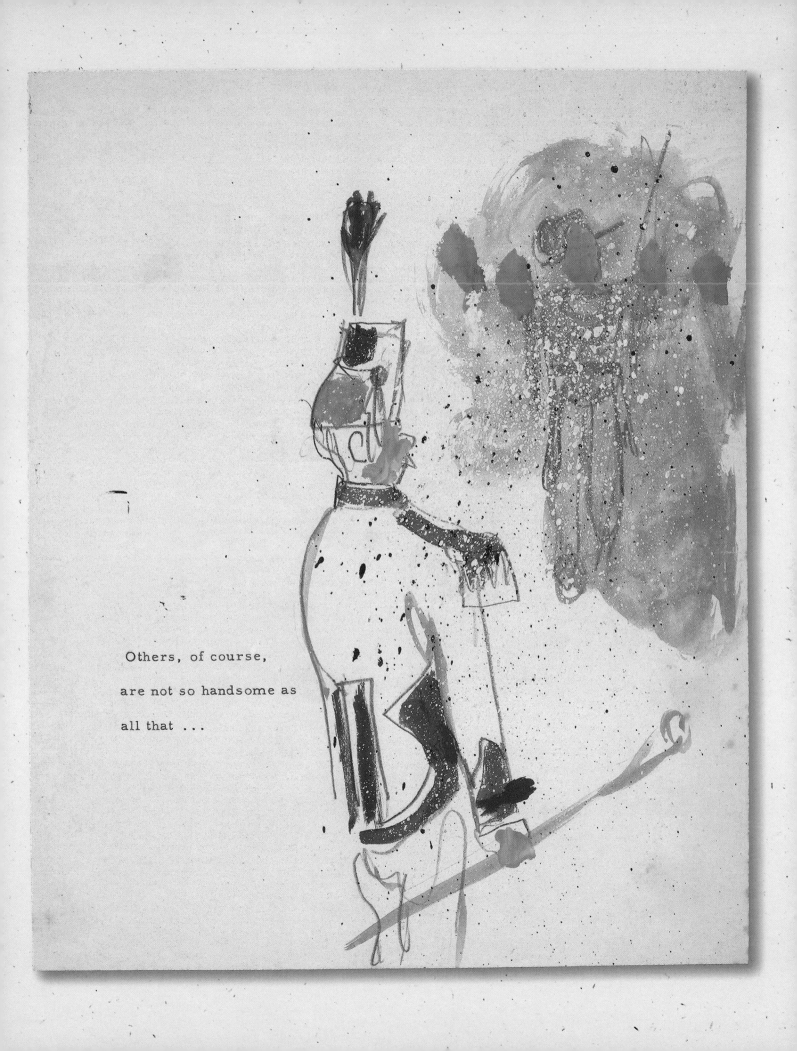

Others, of course,

are not so handsome as

all that ...

THE COSTUMES AS YOU CAN SEE, ARE STRONGLY

EIGHTEENTH-CENTURY IN FLAVOR, BUT THE

ORIGIN OF THE BRAVADEURS IS MANY CENTURIES

EARLIER -- GOING BACK TO THE DAYS WHEN

THE SOUTH OF FRANCE WAS FILLED WITH

HERETICS FANATICALLY OPPOSED TO THE USE

OF IMAGES IN RELIGIOUS WORSHIP. THE

BRAVADEURS WERE A SORT OF VOLUNTEER

ARMY SWORN TO DEFEND THEIR SAINT AGAINST

THE ICONOCLASTS.

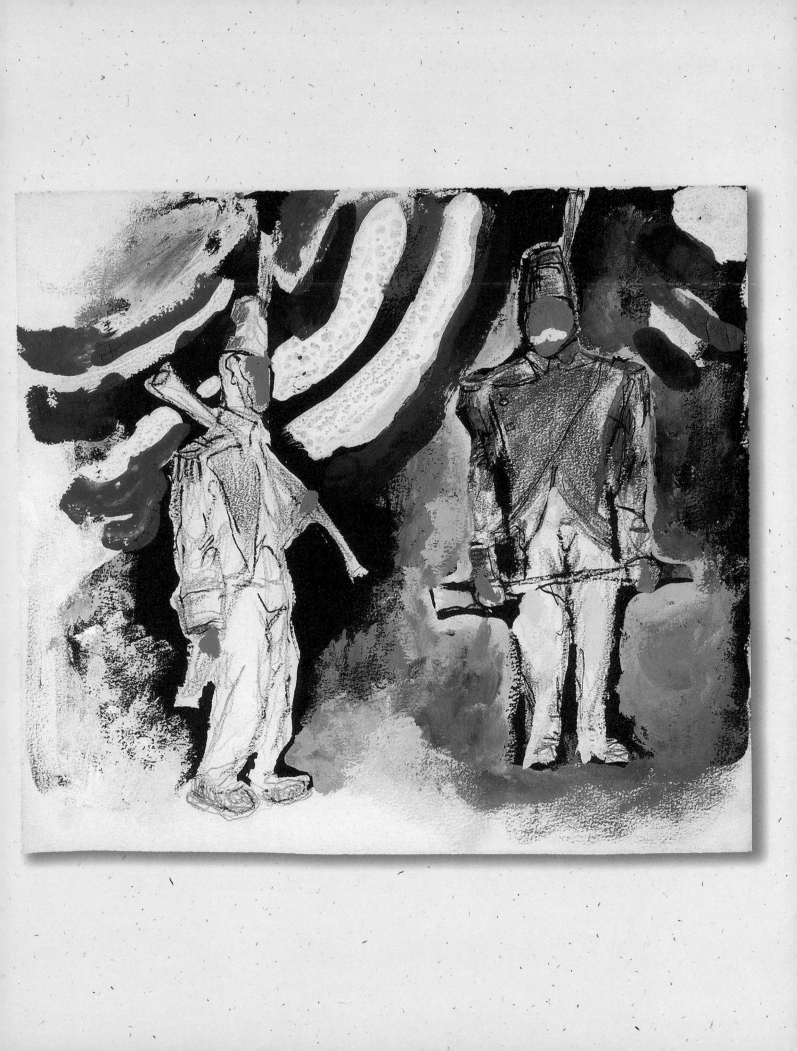

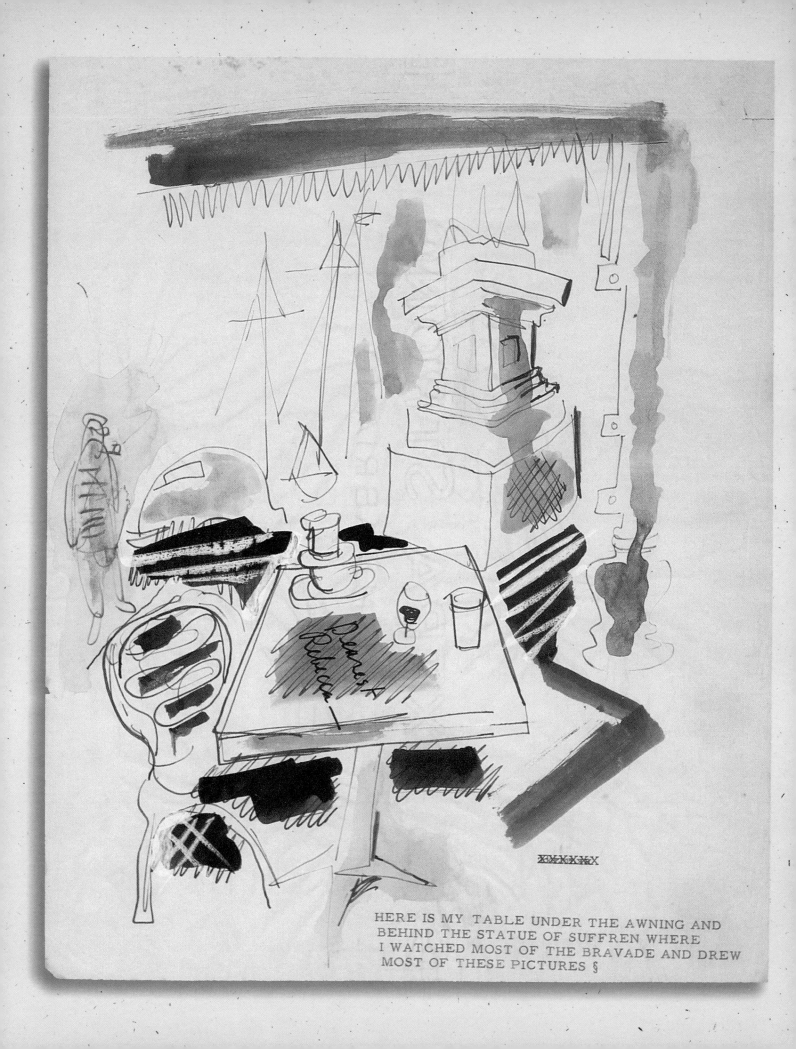

HERE IS MY TABLE UNDER THE AWNING AND
BEHIND THE STATUE OF SUFFREN WHERE
I WATCHED MOST OF THE BRAVADE AND DREW
MOST OF THESE PICTURES §

Sometimes little shrines

to the Saint are put up in the streets ¶

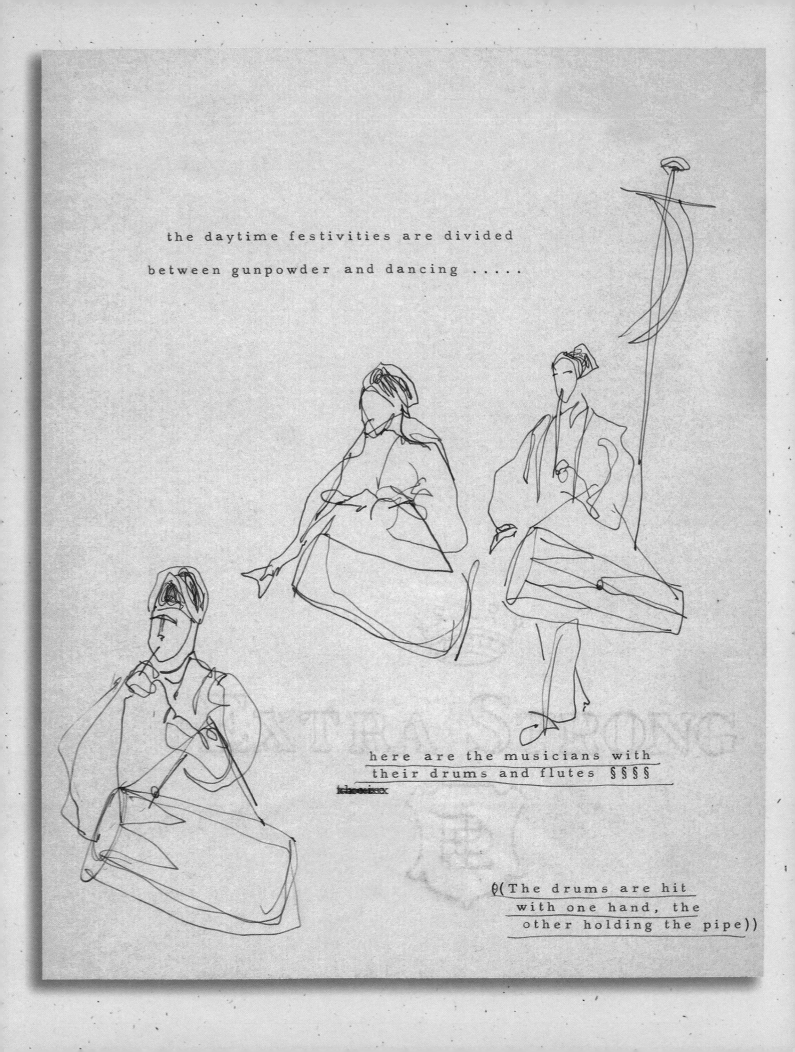

the daytime festivities are divided

between gunpowder and dancing

here are the musicians with
their drums and flutes §§§§

θ(The drums are hit
with one hand, the
other holding the pipe))

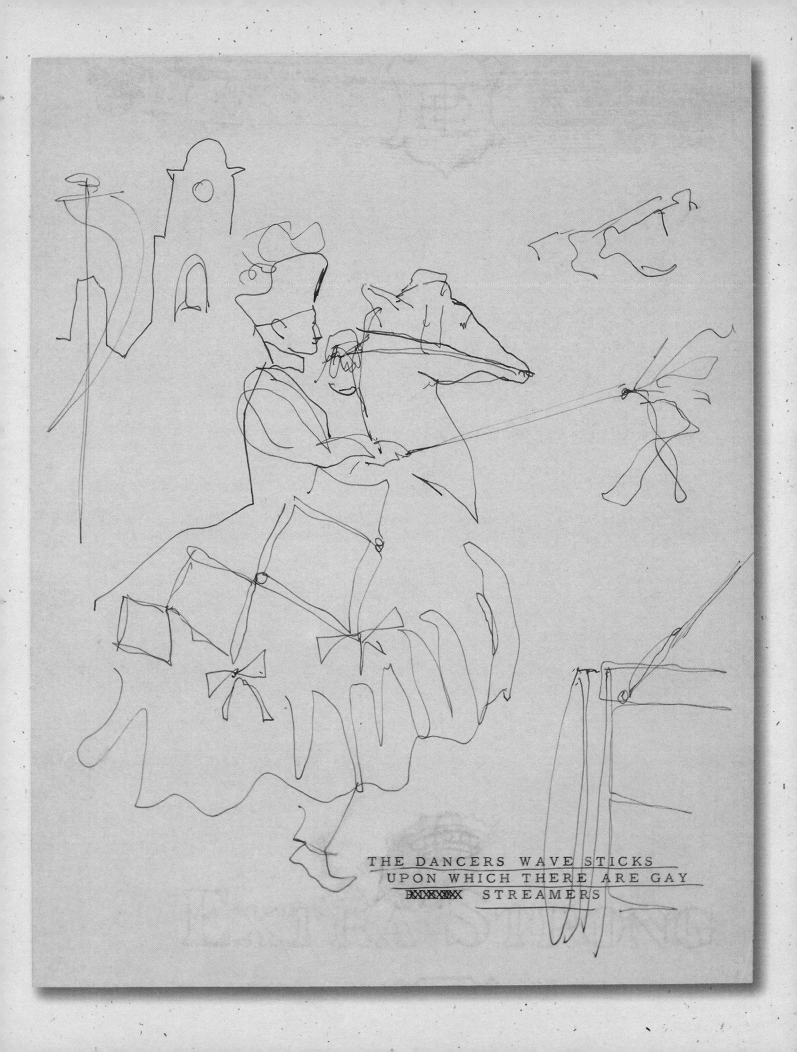

THE DANCERS WAVE STICKS
UPON WHICH THERE ARE GAY
XXXXXXX STREAMERS

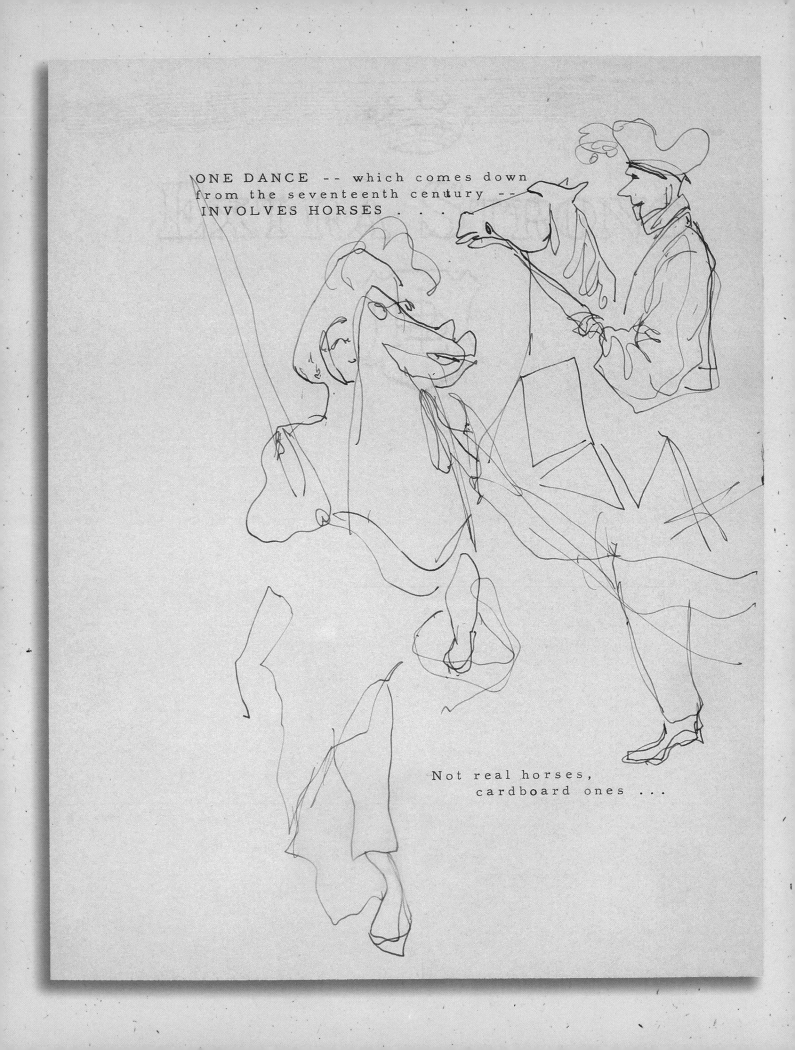

ONE DANCE -- which comes down
from the seventeenth century --
INVOLVES HORSES . . .

Not real horses,
cardboard ones ...

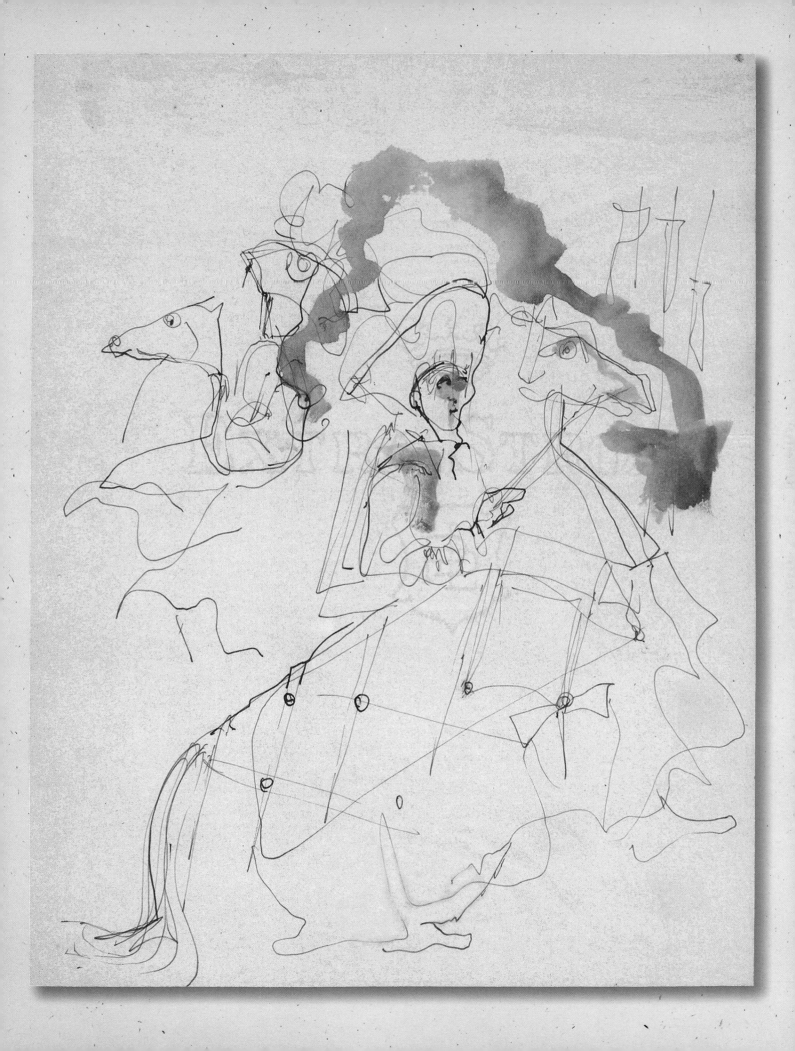

THE HORSES HEADS ARE
BEAUTIFULLY MODELLED

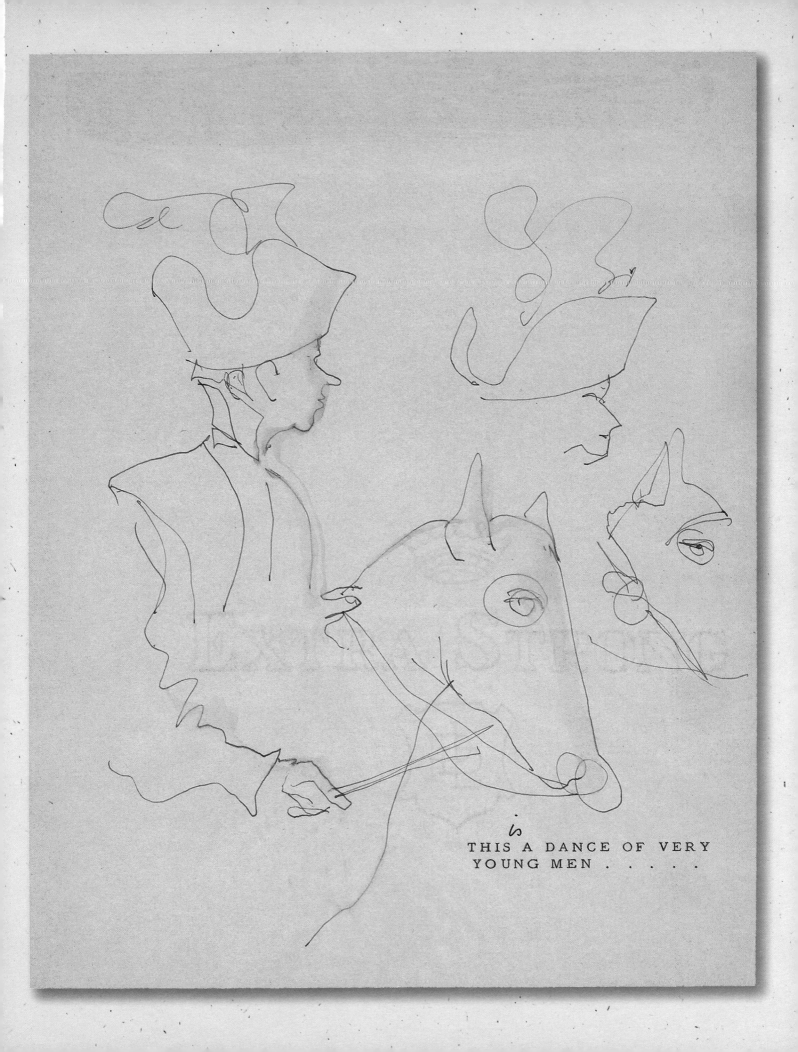

IS
THIS A DANCE OF VERY
YOUNG MEN

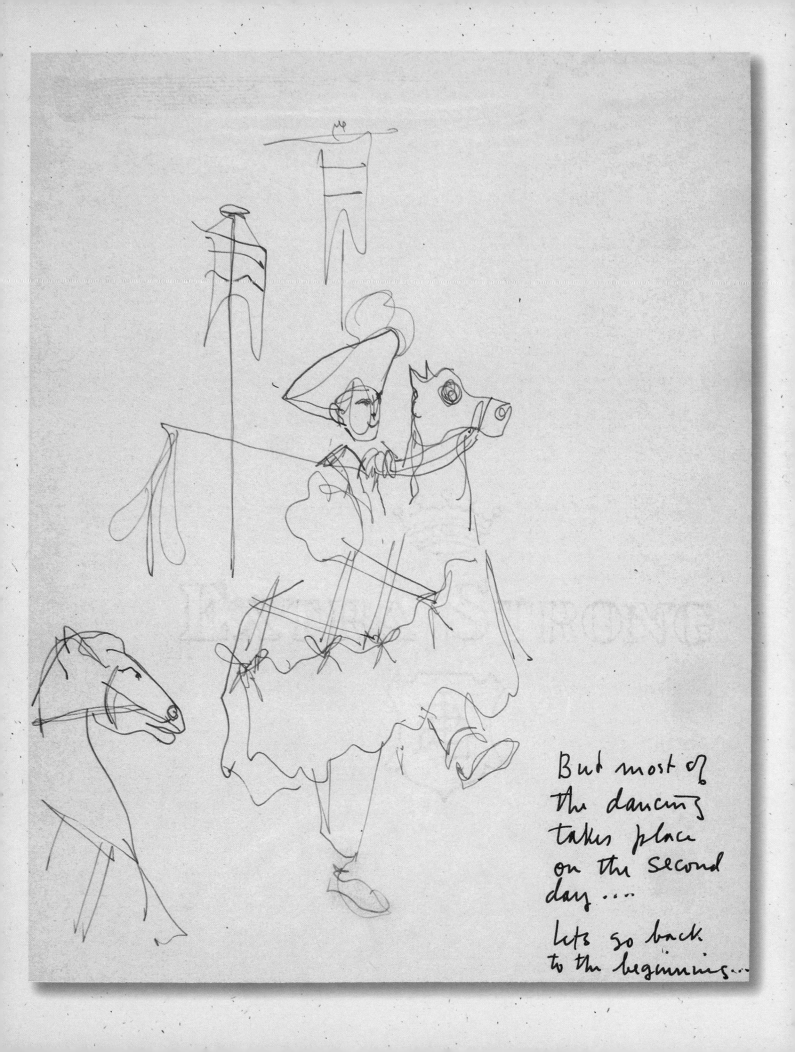

But most of
the dancing
takes place
on the second
day....

Lets go back
to the beginning....

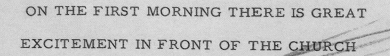

ON THE FIRST MORNING THERE IS GREAT
EXCITEMENT IN FRONT OF THE CHURCH

A BAND OF MUSICIANS PLAYING DRUMS AND

PIPES

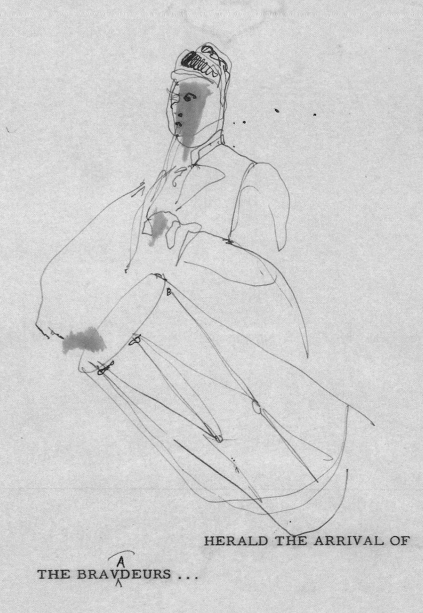

HERALD THE ARRIVAL OF

THE BRAVDEURS ...

While the BRAVADEURS
go into the
Church to
get
SAINT TROPEZ
— the music
continues...

(THIS IS INTENDED TO SHOW
HOW THE DRUM IS BEATEN WITH
ONE HAND AND THE PIPE PLAYED
WITH THE OTHER)

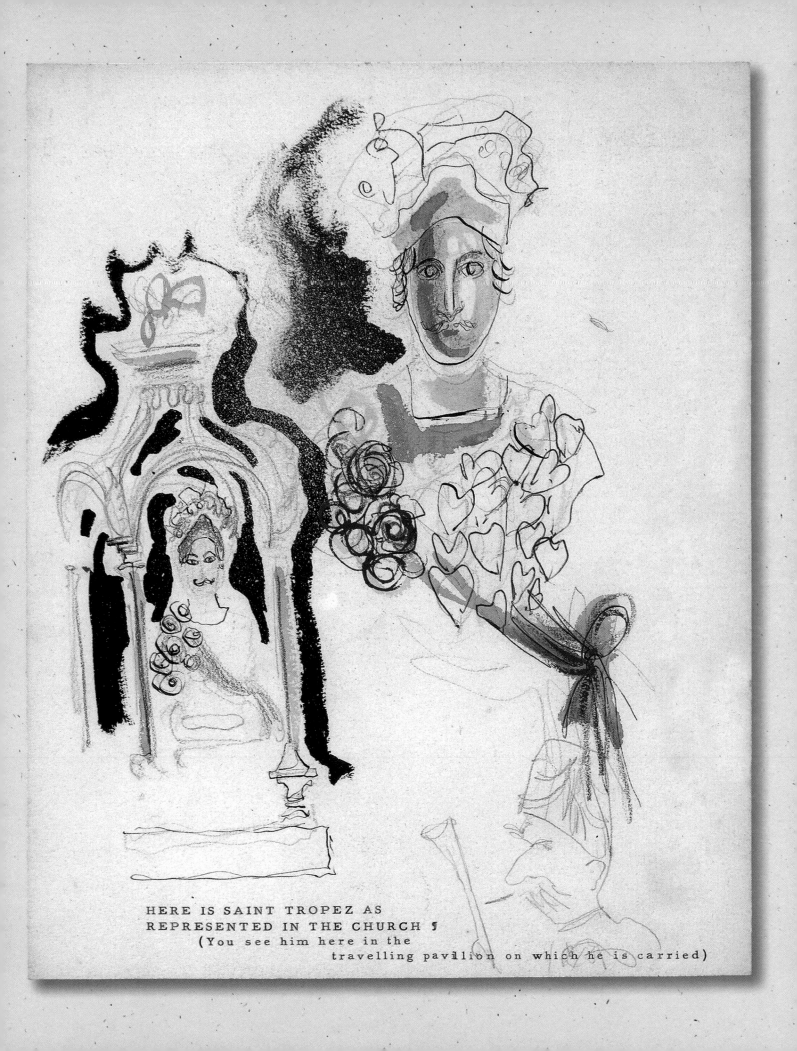

HERE IS SAINT TROPEZ AS
REPRESENTED IN THE CHURCH ¶
(You see him here in the
travelling pavilion on which he is carried)

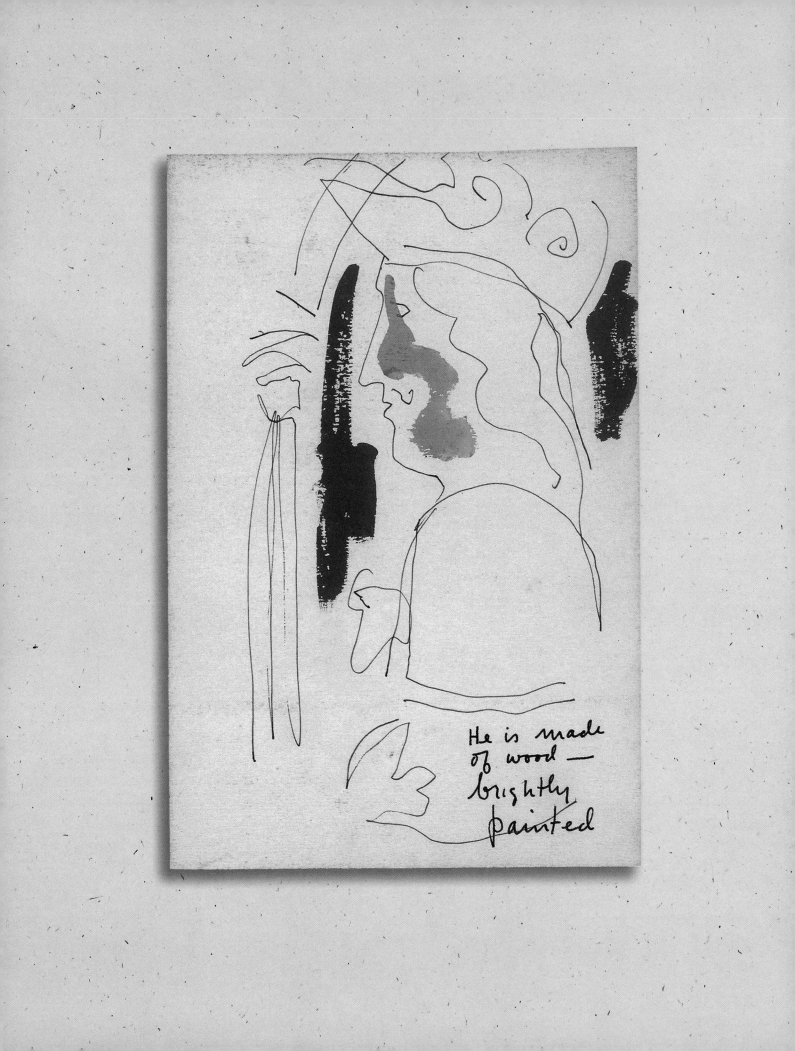

He is made
of wood —
brightly
painted

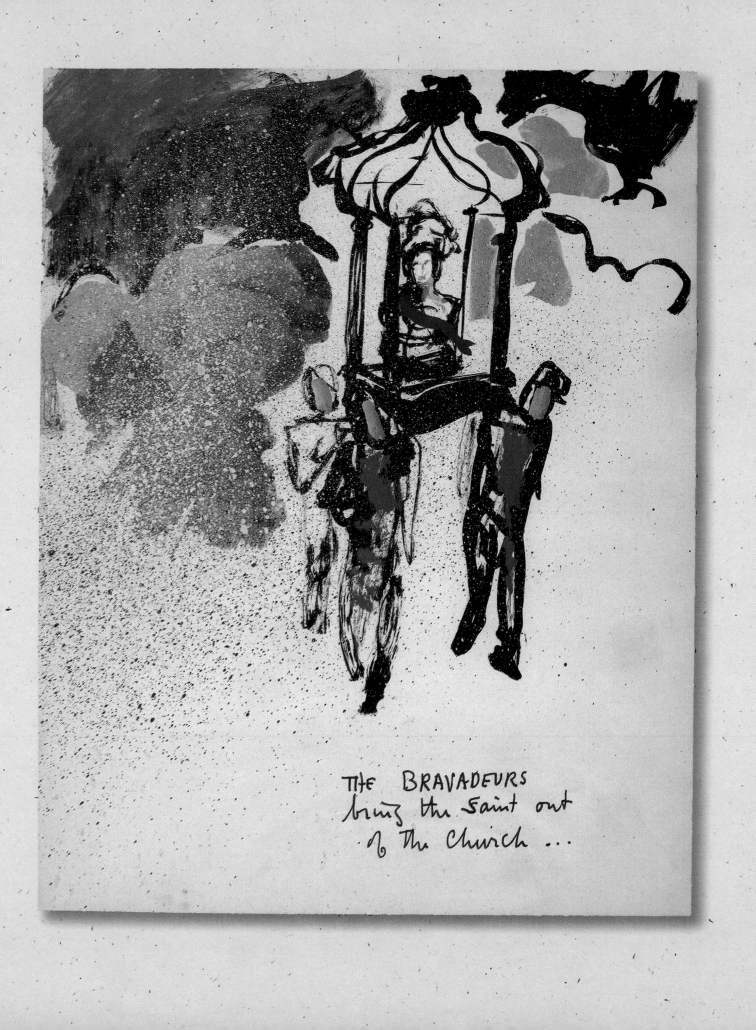

THE BRAVADEURS
bring the saint out
of the church...

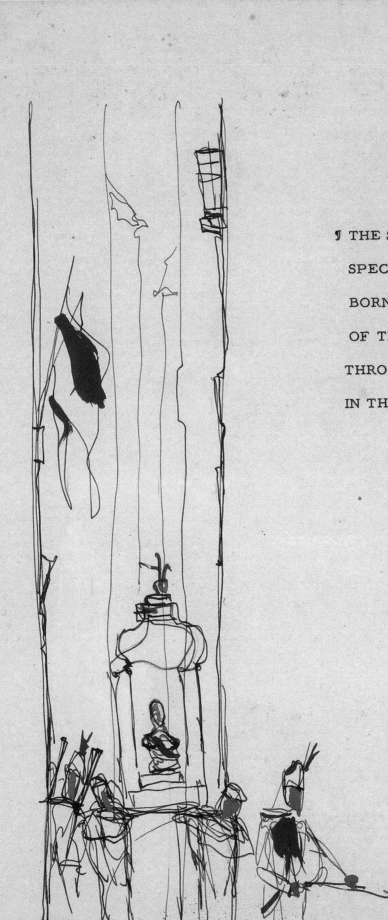

¶ THE SAINT, IN HIS

SPECIAL LITTER, IS

BORNE ON THE SHOULDERS

OF THE BRAVADEURS

THROUGH EVERY STREET

IN THE TOWN ¶

AFTER THE SAINT LEAVES THE CHURCH, AND
WHEN HE IS NOT BEING CARRIED THROUGH THE
TOWN, HE OCCUPIES A SPECIAL POSITION IN
THE SQUARE IN FRONT OF THE TOWN HALL.
HERE A GREAT PART OF THE MOST SOLEMN OF
THE CEREMONIES TAKE PLACE. THE LEADER
OF THE BRAVADEURS IS CALLED "THE CAPTAIN"
A DIFFERENT MAN IS CHOSEN EACH YEAR FOR
THIS, AND OF COURSE IT IS CONSIDERED A GREAT
HONOR.

(The Captain this year was a fisherman.)

WHEN THE SAINT IS

IN HIS MORE OR LESS

OFFICIAL POSITION IN THE SQUARE

HE IS GURRDED BY ~~BRAVYBURS~~

BRAVADEURS ...

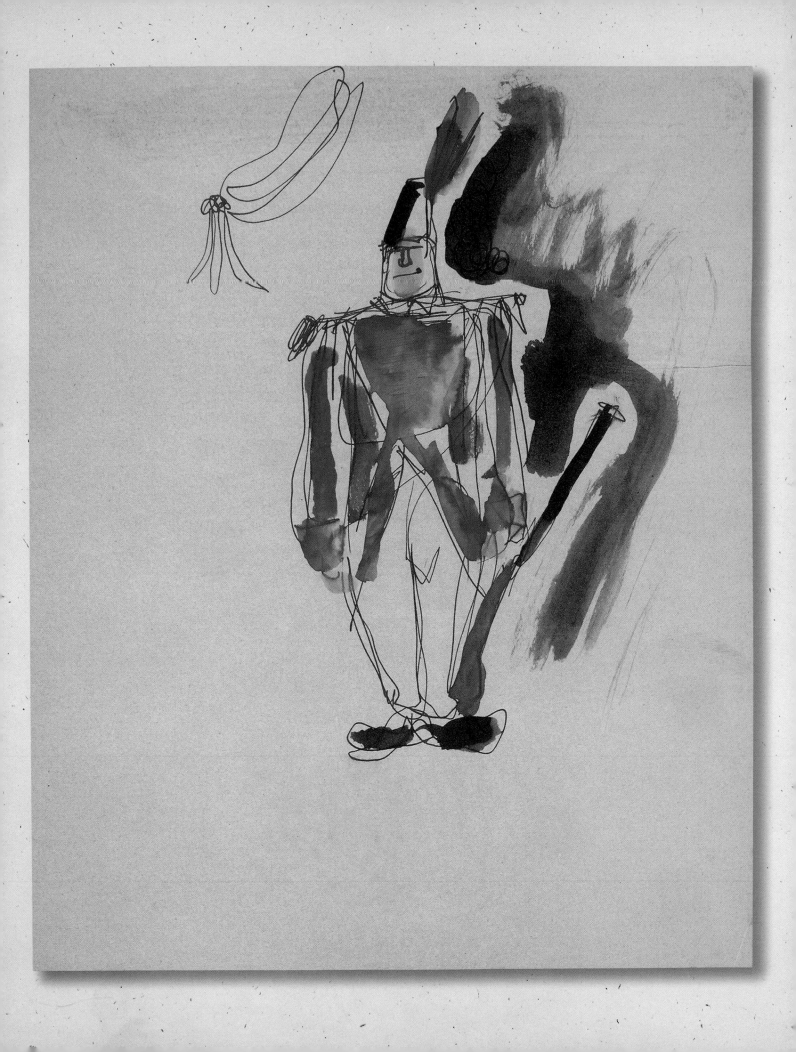

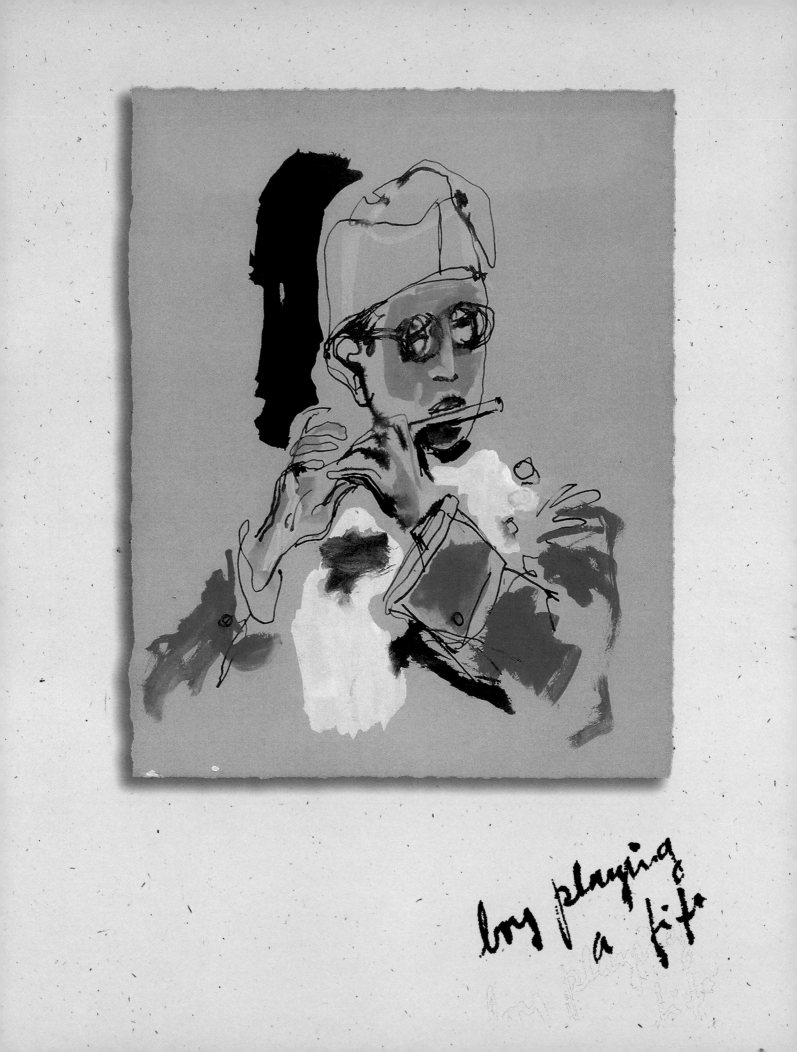

boy playing
a fife

THE "CAPTAIN" OF THE "BRAVADE", HAVING
RECEIVED THE OFFICAL STAFF, OR
SPEAR FROM THE MAYOR, SALUTES
HIM WITH GREAT CEREMONY . . . ¶

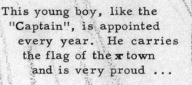

This young boy, like the
"Captain", is appointed
every year. He carries
the flag of the x town
and is very proud ...

Most of the "Bravadeurs"
have been flag-bearers
in their youth

At lunch-time everybody relaxes and talks it over

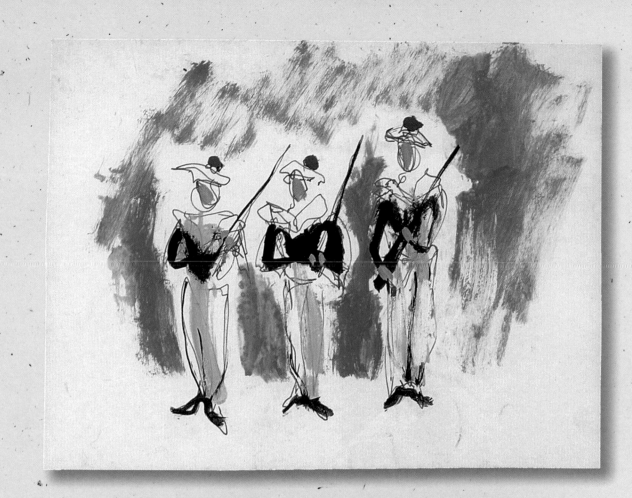

BESIDES THE BRAVADEURS A LARGE GROUP

OF YOUNGER MEN OF THE TOWN ARE DRESSED

AS SAILORS. THEY ARE NOT REAL SAILORS

 BUT WEAR A VAGUELY EIGHTEENTH-CENTURY

FANCY DRESS VERSION OF A NAVAL UNIFORM.

THEY ALSO HAVE GUNS, BUT LONG THIN ONES,

WHICH THEY FIRE AT THE COMMAND OF THE

"CAPTAIN" AND ALSO WHENEVER THEY FEEL

LIKE IT.

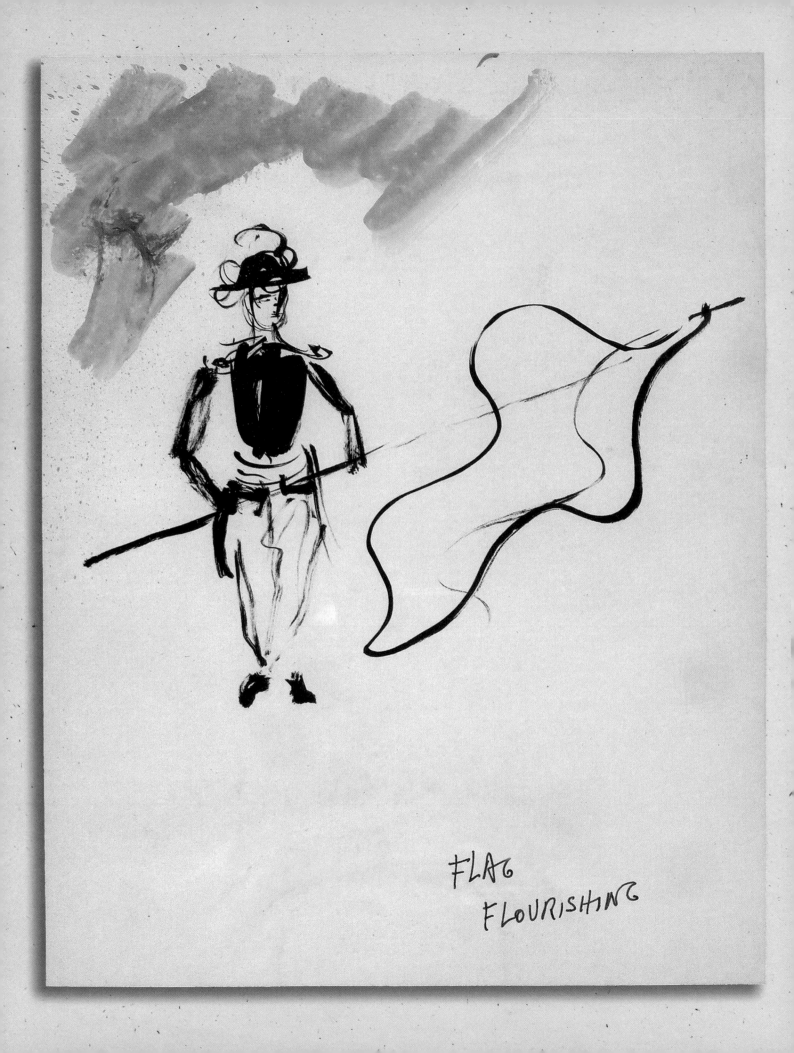

FLAG
FLOURISHING

The spear is
used for giving
the "salute"...

This "salute"
Consists of a series
of movements of
great complexity
which are delivered
with surprising
grace and never
failing gravity.

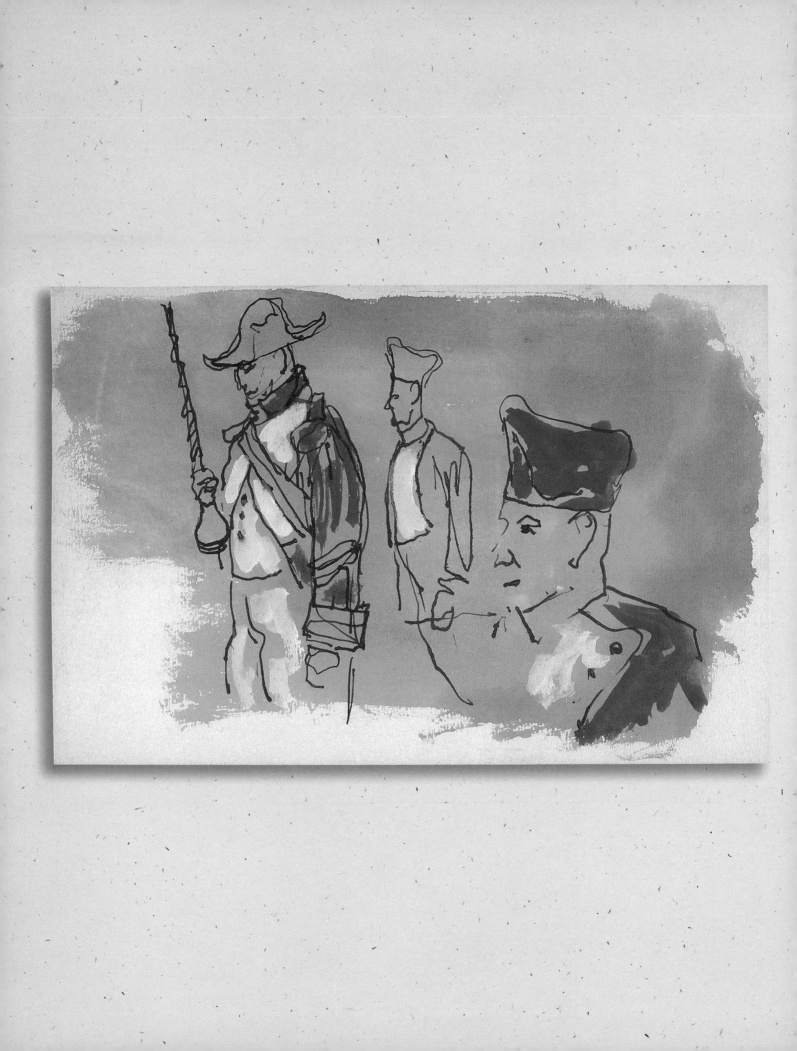

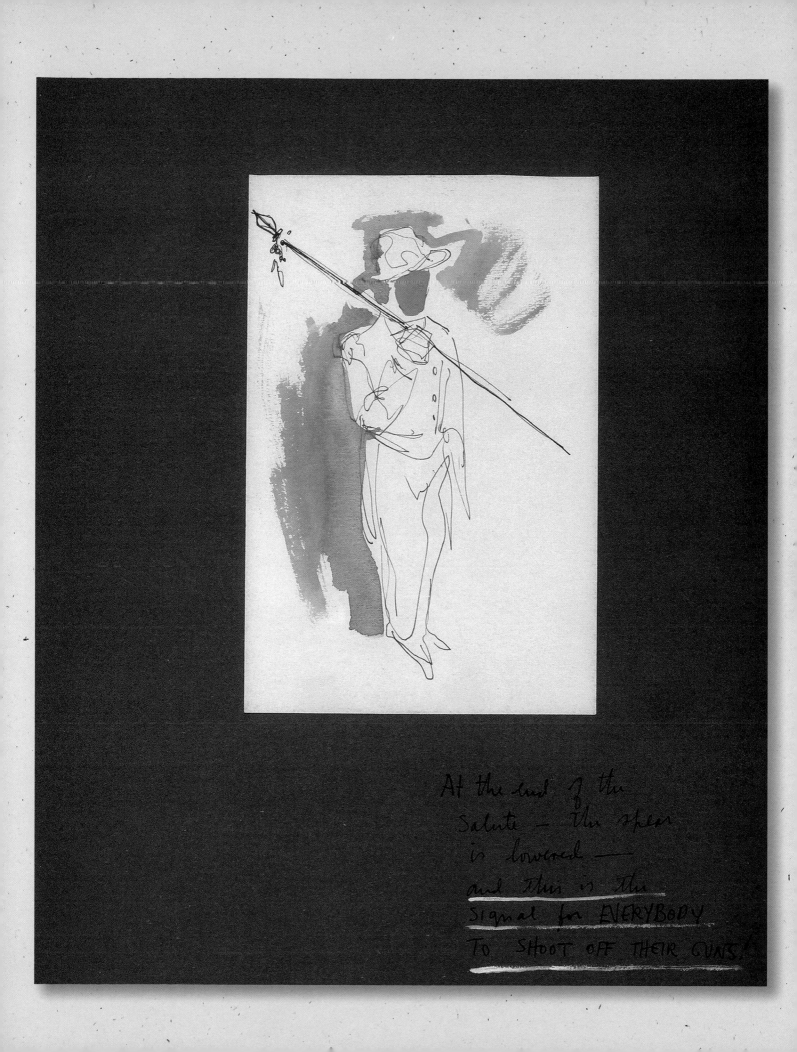

At the end of the
salute — the spear
is lowered —
and this is the
signal for EVERYBODY
TO SHOOT OFF THEIR GUNS.

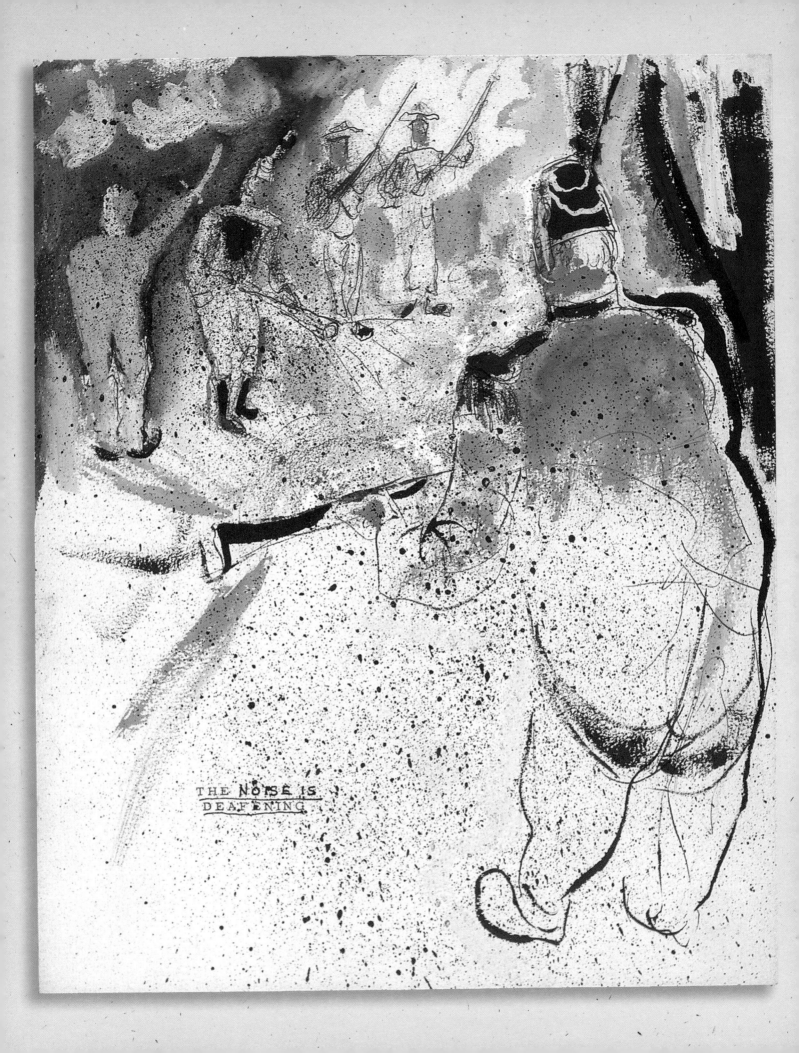

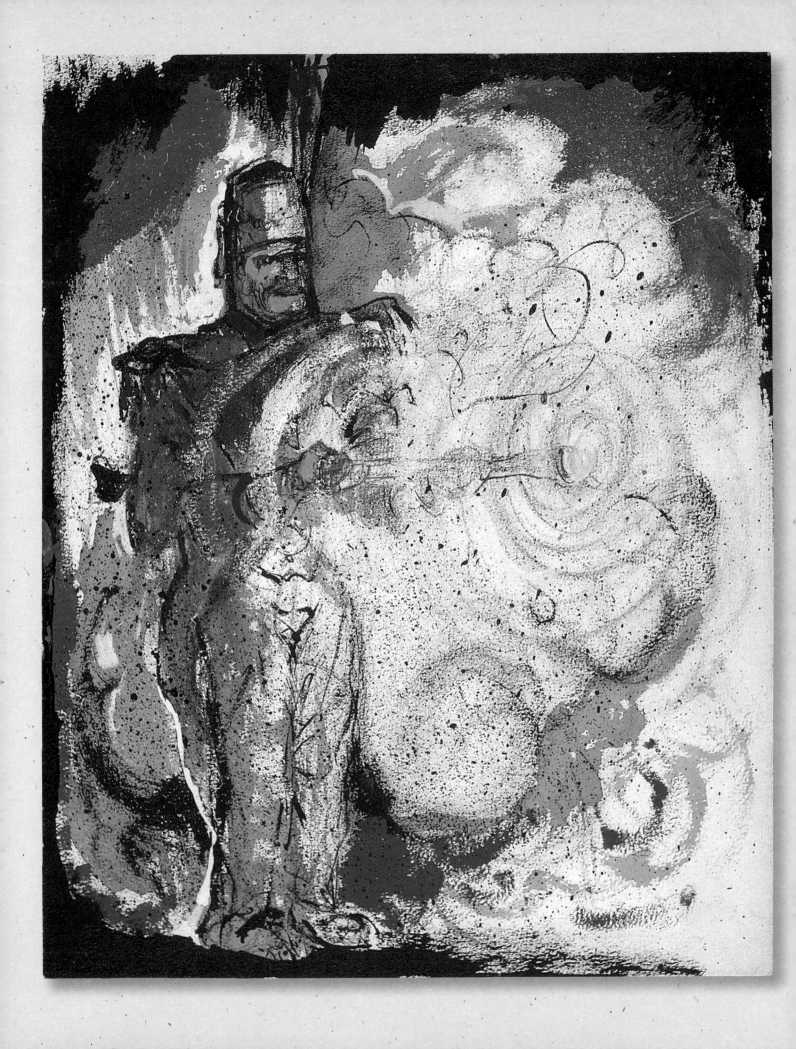

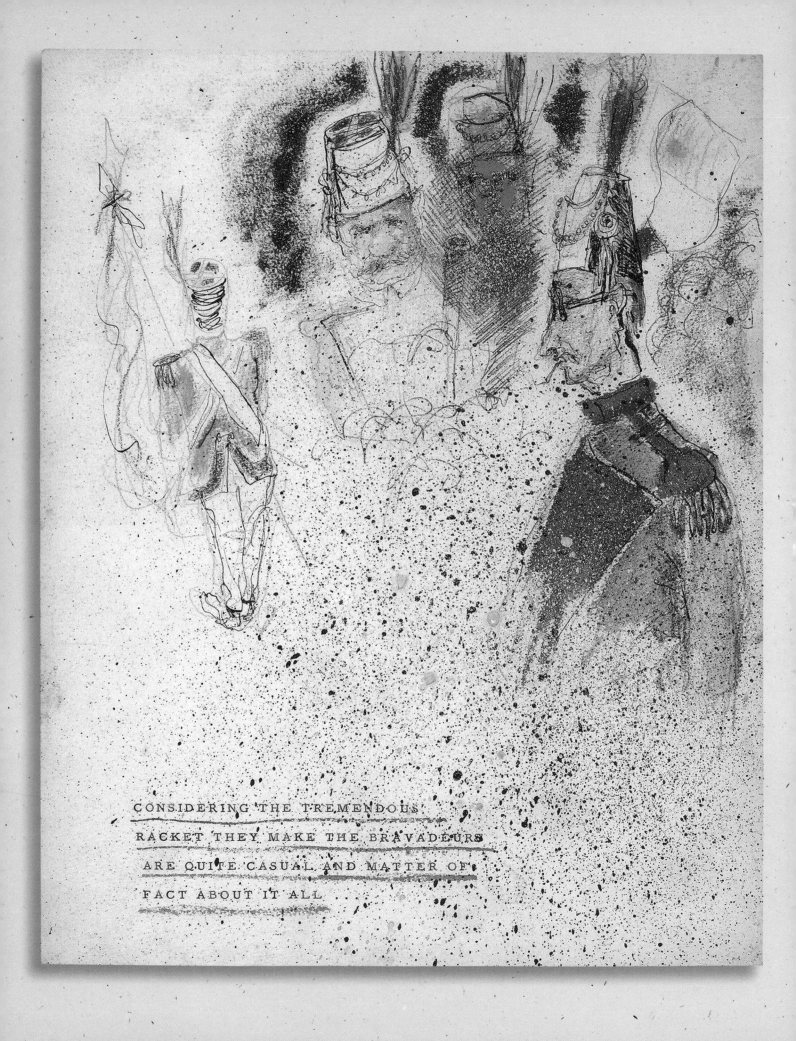

CONSIDERING THE TREMENDOUS
RACKET THEY MAKE THE BRAVADEURS
ARE QUITE CASUAL AND MATTER OF
FACT ABOUT IT ALL

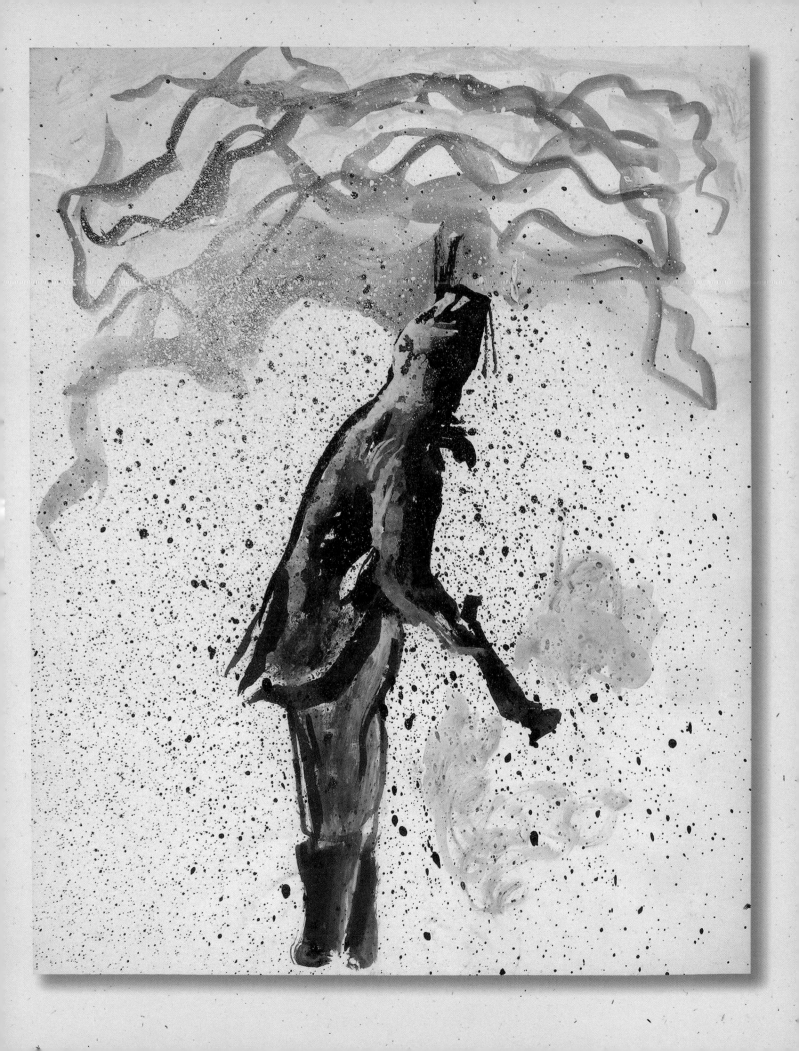

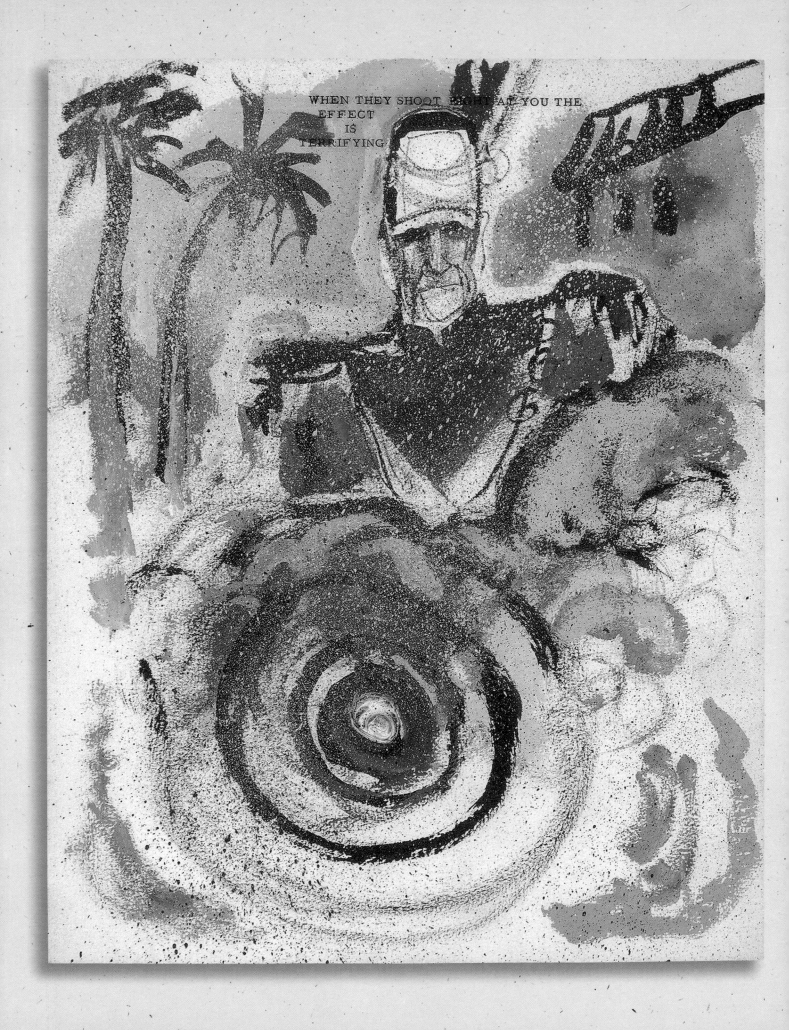

NOWADAYS THE GUNS, A SORT OF BLUNDERBUSS,

ARE LOADED WITH BLANKS, THICKLY WADDED

PAPER AND IMMENSE QUANTITIES OF GUNPOWDER.

FOR THE THREE DAYS AND NIGHTS OF THE

"BRAVADES" THESE GUNS ARE ALMOST NEVER

SILENT. EVERYBODY AND EVERYTHING IS

SALUTED; THE SAINT (REPEATEDLY), THE MAYOR,

VISITING OFFICIALS AND NAVAL OFFICERS, AND

ALL THE LEADING CITIZENS OF THE TOWN.

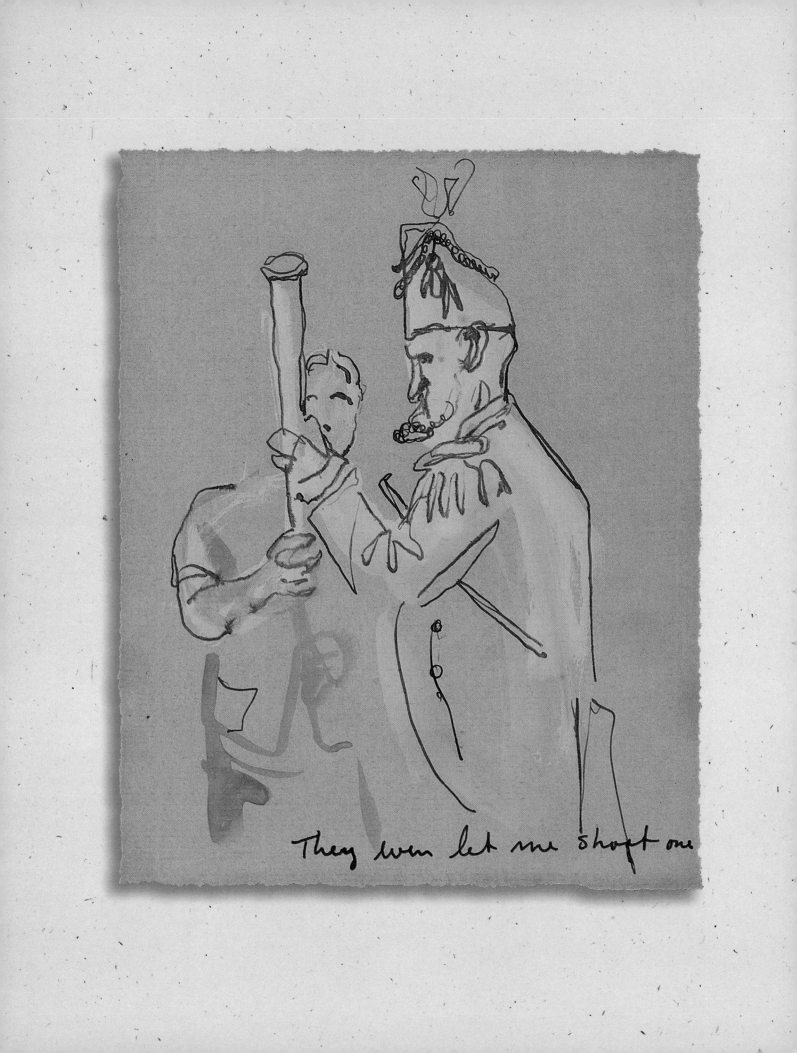

They even let me shoot one

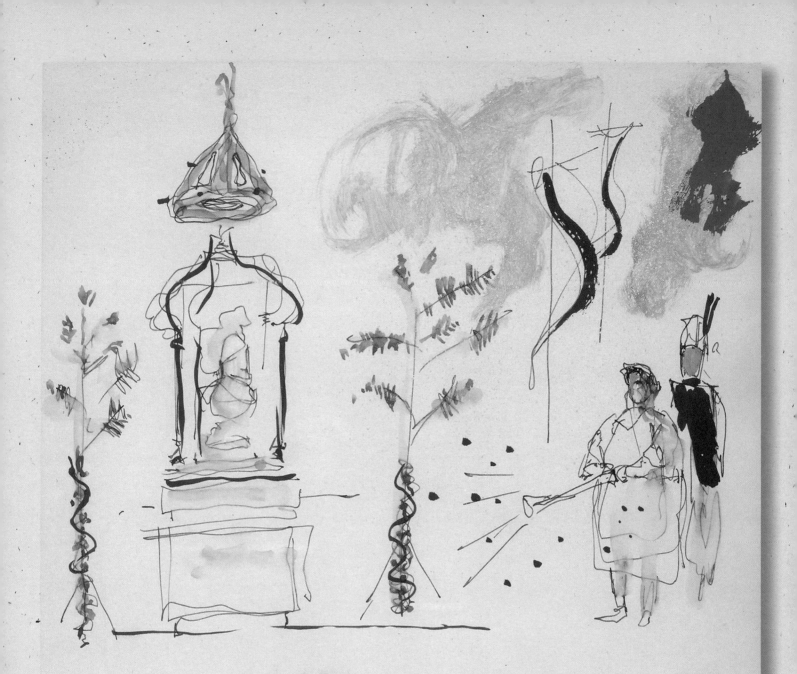

HERE IS THE SAINT IN HIS PLACE OF HONOR IN

FRONT OF THE TOWN HALL ...

THE LADY SHOOTING OFF THE GUN IS PAYING HER

RESPECTS... EVERYBODY IS GIVEN A CHANCE TO

SALUTE THE SAINT AT LEAST ONCE IN THIS FASHION...

(I couldnt find out what the little, Christmasy
sort of trees are intended to signify ...
"just to make it look nice" is what I was
told.... But I'm sure there's a story to
it)

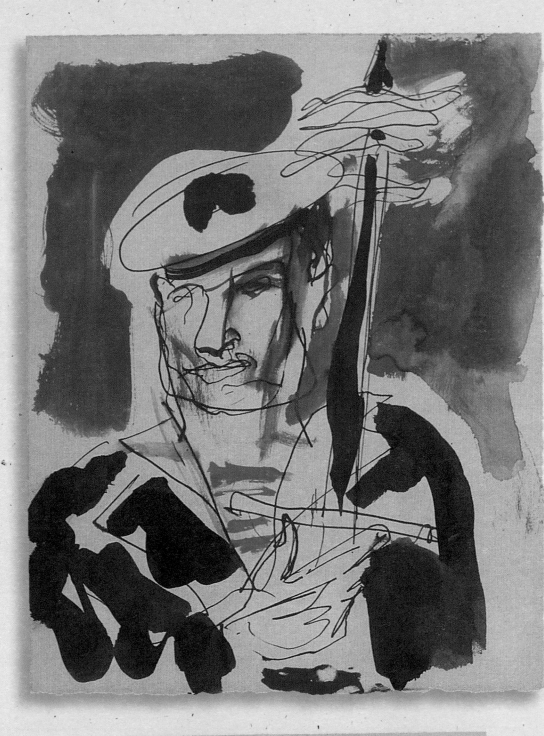

HERE IS ONE OF THE SAILORS WITH A
MESS OF FRIED FISH SKEWERED ON TO
HIS SWORD. (I don't know what this means
except that it is probably good to eat.)

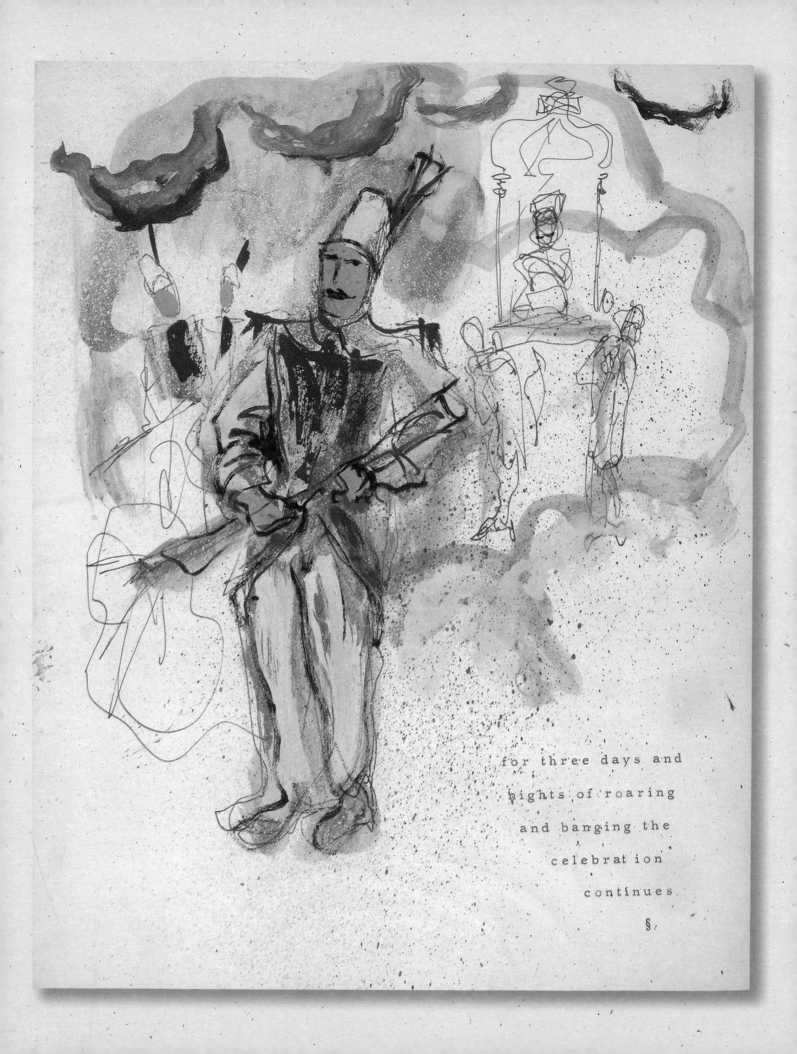

for three days and
nights of roaring
and banging the
celebration
continues.

§.

SPARE GUNS AND PARTS AND EXTRA CHARGES OF GUN-POWDER

ARE CARRIED ABOUT THE STREETS IN A SPECIAL WAGON

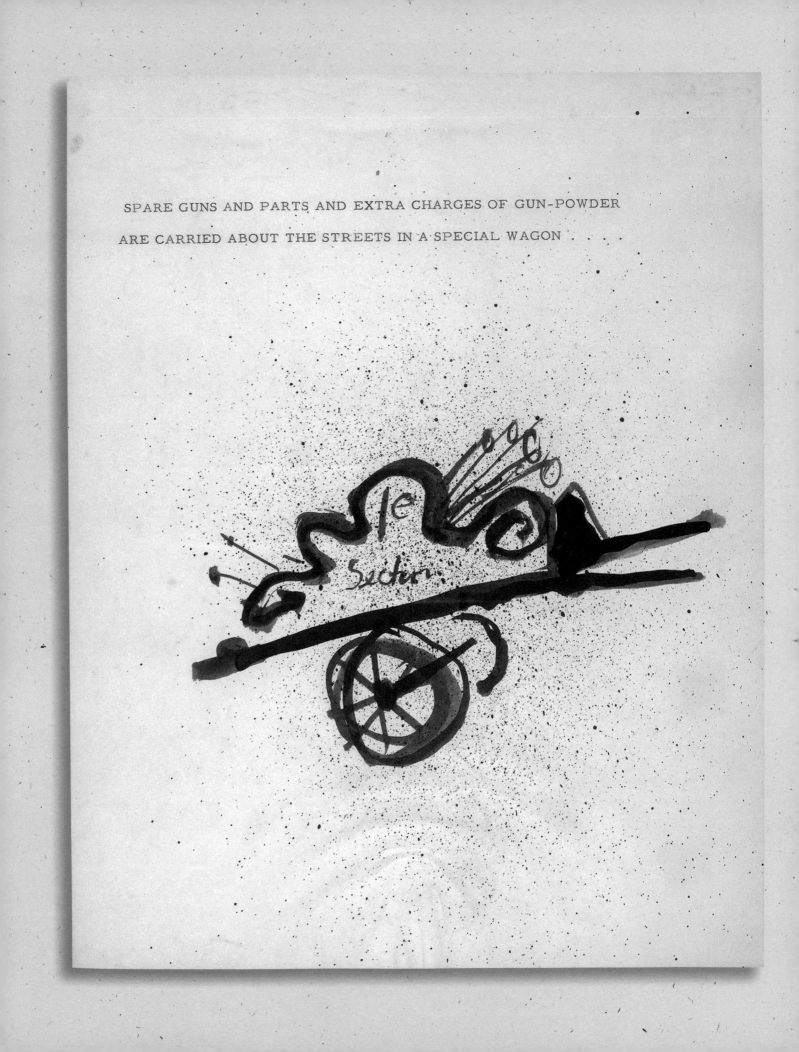

Every once in a
while the parade
stops at the door
of somebody's
house, and an
extra loud racket
is offered up as
a special honor

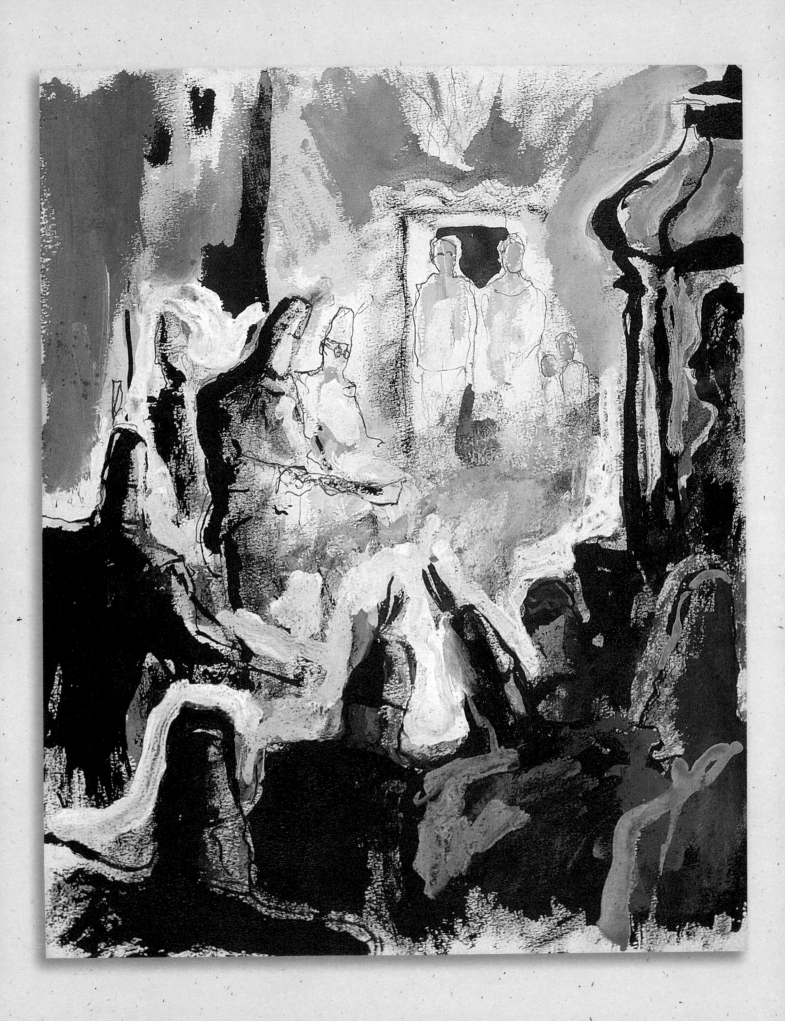

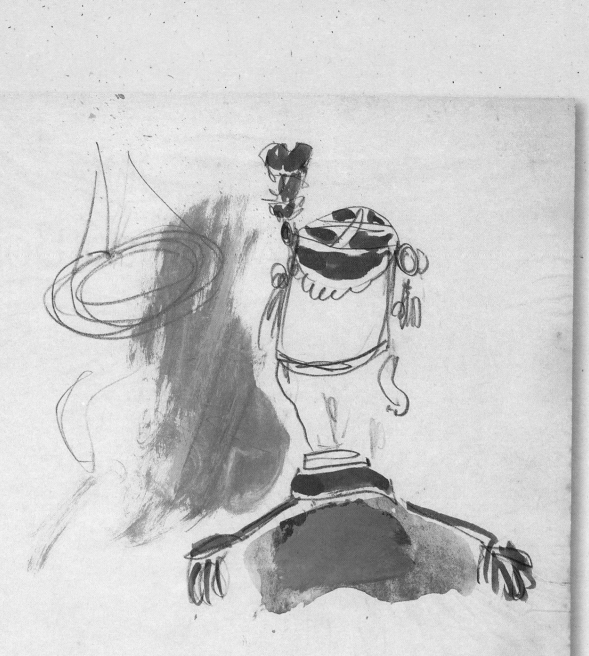

THE OLD GENTLEMAN WITH HIS BACK TO US HERE WAS ONCE

AN UNBELIEVER ... HE MADE FUN OF THE SAINT AND OF THE BRAVADE..

THEN MISERY AND MISFORTUNE CAME TO HIS HOUSE.. SO MUCH OF IT, THAT

HE CHANGED HIS MIND AND ASKED HIS FELLOW-TOWNSPEOPLE TO RE-ADMIT

HIM TO THE RITES OF THE FESTIVAL ... BUT FIRST HE HAD TO STAND

UP IN CHURCH AND MAKE A PUBLIC CONFESSION OF HIS SINS...

(This all happened a long time ago)

AT NIGHT, BY
LIVID LIGHT
OF FLARES,
THE SAINT IS
BORNE THROUGH
THE NARROW
STREETS OF THE
TOWN ♪♪♪♪♪♪

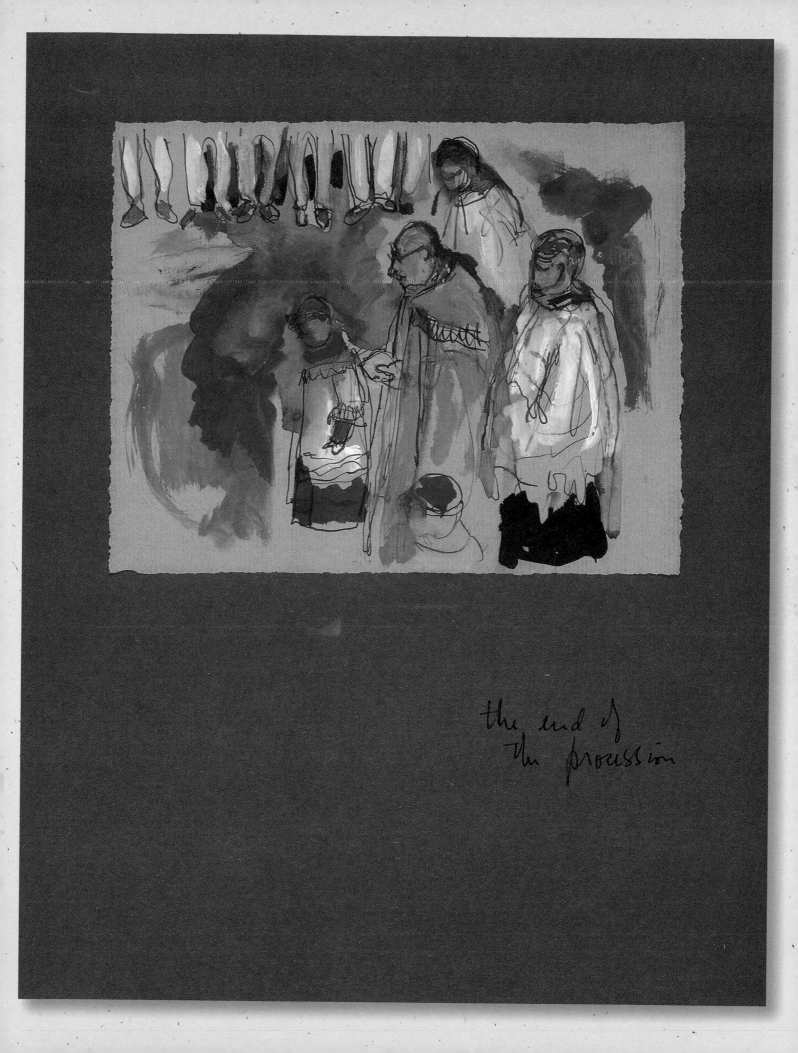

the end of
the procession

THE SAINT IS RETURNED
TO HIS PLACE IN THE CHURCH

EACH "BRAVADEUR" IN TURN TAKES LEAVE OF HIM,
STANDING IN FRONT OF THE IMAGE AND LOOKING
GRAVELY INTO THE SAINTS EYES

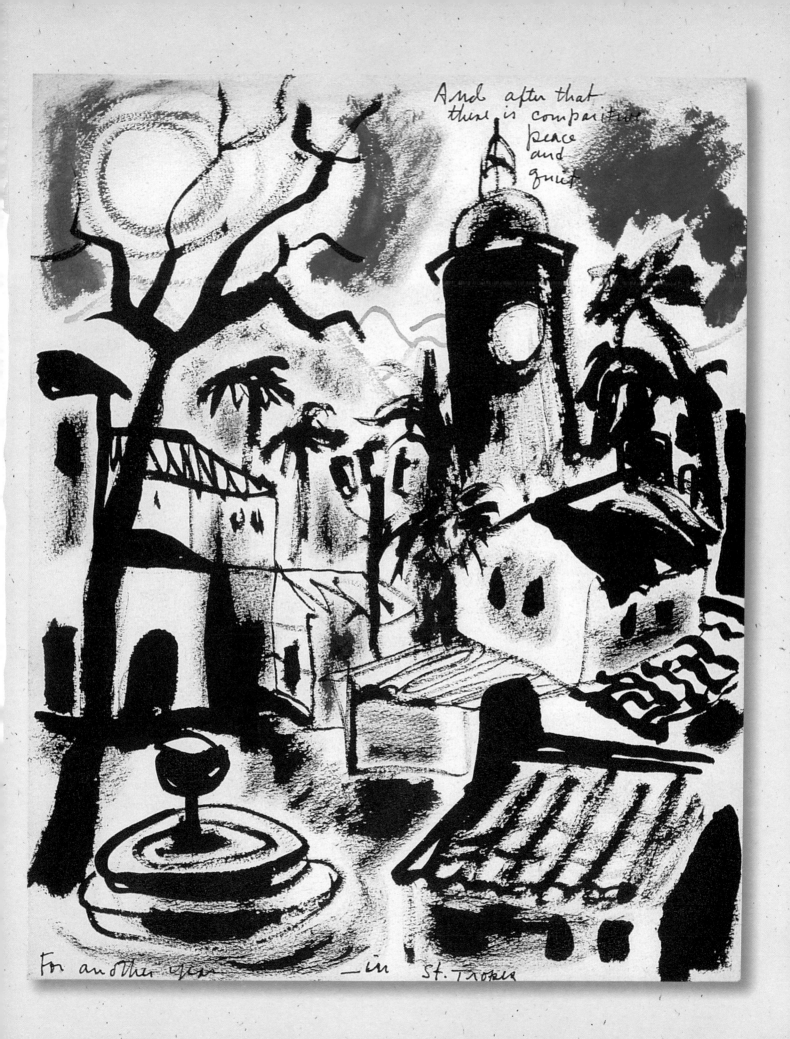

And after that
there is comparitive
peace
and
quiet

For another year — in St. Tropez

Afterword

When Welles sat down in December 1956 to put the finishing touches to his "little picture book" for his daughter Rebecca, he was rather more confident of his own future than he had been for some time. Perhaps that helps to account for the unwonted amount of time he was willing to lay aside for something other than work, in the strict sense of the word.

It was nearly fifteen years since the meteor of *Citizen Kane* had blasted across the sky and summarily disappeared from view. Its reputation continued to haunt him as he tried to proceed with his career: that dazzling debut, praised and publicized to the high heavens, which had nonetheless been a resounding commercial flop. Its successor, *The Magnificent Ambersons*, in many ways a much richer and more deeply felt work, had displeased its preview audiences; while Welles was in Brazil pursuing the *ignis fatuus* of his hugely ambitious part-documentary, part-drama *It's All True*, the film had been mutilated behind his back by the studio and thereafter damned by the critics. He and his Mercury Productions were jettisoned, literally thrown out of the RKO studios, the original discarded footage of *Ambersons* hidden and then destroyed, the remarkable, visionary material he had shot for *It's All True* left to rot until it was stumbled upon and salvaged some twenty-five years later.

Suddenly, by 1943, at the age of twenty-eight, no more than fifteen months after the premiere of the film widely heralded as the greatest ever made, Orson Welles was out in the cold, his career a very public wreck. Not that he stopped working for a moment; but the succession of diverse activities, which had once seemed to be the result of the natural ebullience of a multifariously talented prodigy, now looked confusing and scattered. He was adrift, though magnificently gesticulating. Severed from the continuity and the support of association with a studio, he was now an independent, a role that did not suit him nearly as much as he liked to think it did. He himself loomed larger and larger, dangerously bigger than anything he did. In bewildering succession, he came before the public as a political commentator (columns in *Free World* and the *New York Post*), as a magician (*The Mercury Wonder Show*, sawing his new wife Rita Hayworth in half), and as a B-movie director (*Journey into Fear*, co-directed with Norman Foster), as well as continuing to direct and star in various radio series. Then, in 1946, he returned to the stage, as actor, adapter and director, in *Around the World*, a chaotic, fitfully inspired show loosely based—very loosely—on the Jules Verne novel. Enterprising though it may be in its reconstruction of a vanished world of vaudeville, it was a far cry from the glory days of the Mercury Theatre when Welles had seemed to be the avatar of a theatrical revolution. The critical honeymoon was finally over: WELLESAFLOPPIN' was *Variety*'s succinct verdict.

He returned to movies with *The Stranger*, starring himself and Edward G. Robinson, in a surprisingly sober, well-made, not to say dull film. Under budget and on schedule, it was meant to be his calling card for the studios: a pledge of good conduct. Whatever good it might have done him in that regard was immediately canceled out, in 1948, by the appearance in succession of *The Lady from Shanghai*, visually audacious but narratively obscure, and *Macbeth*, shot on a shoestring for the cowboy studio of Republic in twenty-three days (another bravura display of his ability to shoot quickly and efficiently). A brilliant realization of a primitive world, *Macbeth* was put together in an alarmingly slipshod manner;

Welles, in what was to become familiar pattern, had not supervised the editing himself, too busy earning money acting in a second-rate blockbuster. At around the same time, he played the part with which, to his chagrin, he became above all identified in the popular mind: Harry Lime, in Carol Reed and Graham Greene's *The Third Man*, a curiously Wellesian film (though in fact Welles was on the set for no more than two weeks). Next he wrote and starred in an eccentric double bill of plays consisting of a watered-down Faust story and a slightly windy Hollywood satire, a package that bewildered the Parisian audience before whom it premiered; he took the Faust part of it on tour in Germany with a twenty-minute version of *The Importance of Being Earnest* plus selected highlights from Shakespearean dramas. Dogged and maddened by endless renditions of the famous zither tune from the *Third Man* sound track accompanied by cries of *"Der dritter Mann!"*, he stomped angrily and unsuccessfully around Europe with his odd bill of fare.

Meanwhile, he had started work on his film of *Othello*, which—in another pattern that would become increasingly familiar—was shot across several continents and over many months, with long interruptions. Before the film was even released, he staged the play in London, with himself, of course, in the leading role. The production was not well-received (*Citizen Coon* said Ken Tynan, almost as politically incorrect then as he would have been now). The film was well enough liked when it was premiered in Cannes, despite its technical imperfections, but it had to wait another three years before it was seen in America. Welles was now perceived as a self-imposed exile, both from his country and from his industry. It became increasingly difficult to know how to place him; wayward genius was the usual, unhelpful formula, given weight by his increasingly voluble accounts of himself as *un artiste maudit*, a doomed artist fated to be rejected and misunderstood. Wherever he went, he impressed with the force of his personality and his undoubted gifts, but his struggles to raise funding for his visions foundered on the problem of conveying what his vision might actually be. Just at this moment there was a growing perception especially among the young French filmmakers and critics of *Les Cahiers du Cinema* that he was among the greatest practitioners of his profession, the archetypal *auteur* whose personality is expressed in every frame, every gesture, every phrase of his films. This was certainly, for better or for worse, true of Welles. Admirable though this might seem to Truffaut and Chabrol, the Hollywood of his time was no place for such a creature to work; besides, his explorations of his chosen medium, often in the form of unfinished celluloid sketches, were, or seemed to be, impossibly uncommercial.

He continued active in all media, even finding new ones with which to engage (he conceived and produced a ballet, *Lady in the Ice*, for Roland Petit in London in 1953), and began an interesting flirtation with television by playing King Lear in Peter Brook's truncated version of the play, a respectfully received essay that gave him his second stab (he had played a shortened version on radio in 1946) at a part that obsessed him all his life. The year 1954 was largely spent on shooting and editing *Mr. Arkadin*, which, when released in 1955, was held to be a hollow and lackluster rerun of themes from *Citizen Kane*. Immediately after this disappointment, undaunted and as full of hope for life and art as ever, he married Italian Countess Paoli Mori, to whom a child, Beatrice, was shortly born, and adapted *Moby Dick* into a piece of theater, *Moby Dick Rehearsed*, which is still remembered by those who saw it as one of the supreme theatrical experiences of their lives. In the dual role of Captain Ahab and the actor-manager staging a play from the Melville novel Welles gave by common consent one of his best performances, but despite enormous attention in the press and the appreciation of cognoscenti, it managed only three weeks at the small Duke of York's Theatre in London.

Moby Dick had made him fall in love with the theater all over again, however, and he immediately started planning a big repertory season of classics in New York, with *King Lear* as its climax. In the end, this could not be made to work, and he staged *Lear* alone. It was one of the catastrophes of his career, somehow turned into a circus by his having sprained not one but two ankles at the dress rehearsal and going on to play the First Night in a wheelchair. On the second night, the play was canceled in favor of his performing a potpourri of purple passages from the classics as a one-man show. People in the audience who had followed his theatrical career from its earliest days in the mid-1930s were brought to tears by what they took to be the waste of a mighty talent. Welles, with a family to support and no shortage of dreams to fulfill, started to diversify ever more eccentrically. He moved with his family to Las Vegas, where he appeared in an act which mingled sawing his glamorous assistant in half with speeches from *Julius Caesar*; he appeared in an episode of *I Love Lucy*; he shot a documentary about Gina Lollobrigida; he was a frequent guest and occasional host on television talk shows. There was a brief half-hour film about the three Dumas, a planned series on the life of Churchill, and a pilot for a projected series, shot for the company owned by Desi Arnaz and Lucille Ball, that ranks among the most brilliant examples of the use of the medium in 1950s television. The series never got made, though the pilot—*Fountain of Youth*, from a John Collier novel—won prizes when it was shown two years later as a one-off television film. As usual Welles wrote, narrated, directed and produced it; on this occasion he added a new accomplishment: musical arranger.

And so it continued: stop, start, lucky break followed by disaster, the perpetual quest for backing that would allow him to function again in all his artistic glory. Then in December 1956—just before the Christmas when he sat down with his watercolors and crayons to finish *Les Bravades* for little Rebecca—a real break mate-

rialized. He had agreed to appear in a very ordinary screenplay taken from Whit Masterson's police corruption novel *Badge of Evil*; then Charlton Heston, at the height of his stardom, was approached to appear in the film. Hearing that Welles was cast, Heston demanded to know why he wasn't directing it as well. The producers reacted, according to Heston, "as if I'd suggested my grandmother," but on reflection conceded that it might not be such a bad idea. Welles was duly contracted as director and began the process of remaking the script to his own artistic requirements. The film was made the following year; it was a flop, but today, as *Touch of Evil*, it is among the key works of American postwar cinema, endlessly imitated, with an opening sequence that haunts the imagination of every new generation of directors.

All that, however, was in the future. Now, in December 1956, was the sweetest moment, when everything was to be won, when the project at hand was rich with possibilities and financing was in place. Then it was that Welles reached for the watercolors, exercising the talent he prized least highly, that of painter, draftsman and designer, one he practiced as long as he lived, from the astonishing marginal sketches in *Everybody's Shakespeare* when he was sixteen, through the costume designs for *Dr. Faustus*, the annual Christmas cards sent to friends, and the lavishly and brilliantly executed drawing for the issue of *Vogue*'s Paris edition that he supervised in 1982. His painting and drawing is consistently witty, well-observed, evocative and quite remarkably assured. Whenever he wished to make an affectionate personal gesture, this was the medium he chose. In *Les Bravades*, Rebecca Welles was the recipient of one of the largest and most bountiful of those gestures. How enchanting that we can now share it with her.

Simon Callow
Fall 1996